BEER, ART
AND PHILOSOPHY

A MEMOIR
TOM MARIONI

**The Act of Drinking Beer with Friends
Is the Highest Form of Art**

**Introduction by
THOMAS McEVILLEY**

ISBN 1-891300-17-2
Published by Crown Point Press
Book design by Tom Marioni
Produced by Sasha Baguskas at Crown Point Press
Printed in China through Colorcraft Ltd., Hong Kong

Crown Point Press
20 Hawthorne Street
San Francisco, CA 94105
(415) 974-6273
www.crownpoint.com

for the one and only, the lovely and talented Kathan Brown,

and

my three boys and my three brothers

ACKNOWLDGEMENTS

Special thanks to editors
Kathan Brown, Judith Dunham, Jennifer Rodrigue
Production, Sasha Baguskas
Design, Tom Marioni
Cover photograph, Philip Cohen

Thanks to Graduate Bartenders
Joyce Umamoto, Fran Valesco, Mari Andrews, Mike Dyar, David Jones,
Bob Bechtle, John Moore, Jennifer Rodrigue, David Ng, Sono Osato,
John Held Jr., Patricia Tavener, Susan Middleton, Charles Linder,
Diane Roby, Bill Morrison, John Kouns, Manuel Lucero, Paul Karlstrom,
Cheryl Meeker, Kim Turos, Greg Edwards, Ruth Braunstein,
Evelyn Koeppel, Lorna K., Susan Magnus, Michelle Davis,
Stephen Goldstine, Alice Shaw, Ishan Clemenco, Paul Kos, Dan Max,
Paula Newman, Sharon Grace, Bob Dreher, Kent Roberts, Frank Born,
Ken Goldberg, Alissa Anderson, Bao Vo, Edward Stanton, Yoshi Wada

Guest Bartenders
Howard Fried, David Ireland, Masashi Matsumoto, Paul Mullowney,
Flicka McGurrin, Valerie Wade, Lydia Modi-Vitale, Rebecca Solnit,
Shmulik Krampf, Mojca Pungerer, Walter Kratner, Danielle Klinenberg,
Diana Fuller, Ann MacDonald, Dieta Sixt, Synne Bull, Dragan Miletic

CONTENTS

INTRODUCTION

Thomas McEvilley

Tom Marioni has been hailed as Northern California's foremost Conceptual artist, and there is a special distinction to that now that the region's pioneering place in the history of Conceptual Art is beginning to be understood. As early as the 1960s, New York City laid such a strong claim to being the proper home of Conceptual Art that the terms "California" and "Conceptual Art" were seen as contradictory, almost as a kind of joke. Beginning in 1968, Marioni found a way to become that contradictory being—Northern California's foremost Conceptual artist—by affirming the joke and going with it, making it a fruitful part of the art material.

Marioni was born in Cincinnati in 1937, had a Catholic upbringing and studied violin at the Cincinnati Conservatory of Music, then painting and sculpture at the Art Academy. During a stint in the army he painted murals in various buildings on the base. Then in 1963, after his military service, he settled in San Francisco where he has lived ever since.

In terms of the history of art, the moment of Marioni's arrival was the beginning of a new era. All the rules were about to be rewritten, and he would be a part of it. In 1963 the American Fluxus artist Henry Flynt published the term "Concept Art," which four years later Sol LeWitt would alter to Conceptual Art. Rooted in Dada, the new art had begun to reveal itself in the early 1950s (in works like Robert Rauschenberg's *Erased de Kooning Drawing*, 1953) and by the end of the '60s was well under way. In those years, the new medium had appeared in various parts of the world—Brazil, Japan, and much of Western Europe as well as the United States. But

though recently it has been recognized that Conceptual Art was a global phenomenon from the beginning, in the United States it was regarded as a particular province of the culture of New York City. California was very far away, not only geographically but culturally as well. When Conceptual Art sprang up in California too, something of a rivalry, not entirely without rancor, was under way.

In a sense, the classical Conceptual Art of New York City in the late 1960s grew from the tradition of the sublime, which had been the preoccupation of the Abstract Expressionists. Those painters, who had entered their maturity in the late '40s and were by this time at the end of their wave of history, had created what Harold Rosenberg called an essentially theological movement emphasizing visual embodiments of the sublime. The sublime, as defined in the tradition of art theory by Edmund Burke, is a grandeur so great as to be out of human scale and thus innately threatening and dangerous to the ego. The sublime is like the universal; an individual ego could lose itself within it. This concept had dominated the late Romantic period, which included Abstract Expressionism as its last great manifestation. The solemnity and reverence with which the Abstract Expressionists and their audiences regarded the aesthetic experience was, as Rosenberg said, more or less a religious feeling, a kind of awe before the secret overpowering might of reality.

Early Conceptual artists in New York City spurned the Abstract Expressionist cult of aesthetic feeling, yet still maintained something of the awe of the sublime. This was done by translating the sublime from aesthetic to cognitive terms. For Joseph Kosuth, Lawrence Wiener, Robert Barry, and others of their New York generation, the awe of the sublime focused not on the feeling of aesthetic joy but on the fundamental workings of conscious-

ness. As consciousness was coaxed through a deliberate series of cognitive acts, Conceptual Art celebrated the truth of the universe no longer as a kind of feeling but as a kind of knowing. In California the situation was somewhat different.

The first California works that can clearly be called Conceptual Art were made by John Baldessari in Southern California in 1966-67. Unlike the Conceptual Art being made in New York, they featured humor. Many of the works were, or involved, jokes about the radical changes taking place in the theory of art at that moment. These include the series of paintings made by a sign painter with messages like *Work with Only One Property*, in parody of the dominant early Conceptual mode of the monochrome. This type of work was ill received in New York, where one did not joke about the underlying cognitive processes that make everything make sense. Kosuth, in his influential essay *Art after Philosophy* (1969), actually called Baldessari's work not Conceptual Art but cartoons of Conceptual Art.

Marioni's Conceptual work began to come on the California scene at this time, and also tended to involve humor as a part of the fundamental approach of art to reality. Such work, while it might have been regarded as light or frivolous in New York in the '70s, was received enthusiastically in Europe, where the otherness of California (which was related as much to Asia as to Europe) exercised a powerful mystique. This mystique was being stimulated by light and space art from Southern California at the same time. Marioni, perhaps partly because of his years in the military in Germany, had already developed a personal sense of involvement with European influences and attitudes. He had been won over by the accomplishments of Marcel Duchamp, Joseph Beuys, and Yves Klein. Like

Baldessari's, Marioni's work in time overleapt New York and found a home in the European side of contemporary art history.

Conceptual Art made in New York was linked early on to the British Art and Language Group, while California Conceptual Art established links with Continental European traditions such as Arte Povera (in Northern California) and European photography-based Conceptualism (in Southern California). For one thing, on the Continent there was more affirmation of humor than in New York. The career trajectory of overleaping New York City and finding an audience in Europe became characteristic of West Coast art, where not only the humorous type of Conceptual Art but also other art from California tended to follow this course. In addition to Baldessari and Marioni, the careers of Ed Ruscha and James Lee Byars (who had some connection with California), along with space and light artists Robert Irwin, Doug Wheeler, and Eric Orr, followed this trajectory. Major collectors, including Count Giuseppe Panza di Biumo, worked this area of culture with considerable effect.

Some of Marioni's early Conceptual works can be described as in the mainstream, in that they pursue the central New York theme of the decon- struction of cognition and representation. In the 1970 work *Process Print*, for example, Marioni ran a hundred sheets of paper through an offset press with no image on the plate, the ink gradually taking over the whole surface. Ian Burn's *Xerox Book* (1968) was a New York equivalent, in which a sheet of blank paper was Xeroxed, then that sheet Xeroxed, and so on, through a hundred generations, the hundred pages then being bound as a book. Marioni's pages were meant instead to be mounted sequentially on a wall, where they created landscape like images.

Others of Marioni's works comprised a critique (or a parody) of the very idea of a mainstream of Conceptual Art. The edge of humor in Marioni's works of the early '70s demystifies, diminishes, and brings down to earth the solemnity of the sublime. A work of 1969, for example, *Abstract Expressionist Performance Sculpture*, was a roll of film to be pulled unexposed from its container and flung on the floor. The themes involved— negating crafts by preserving the art material as raw matter, negating intention by inviting the intervention of chance, and negating ego by unquestioningly accepting the result—were major conceptual themes of the moment. Similar points were being made in works like Dennis Oppenheim's *Cancelled Crop* (1969) and *Reverse Processing* (1970), Bernar Venet's *Heap of Coal* (1963), and Robert Smithson's *Asphalt Rundown* (1969). In all these works, a material was kept from processing and retained in its natural state with an implicit critique of culture's tendency to interfere in nature. These others, however, could be described as somewhat grandiose embodiments of the theme, while Marioni diminished his demonstration in scale to the point where it becomes a tiny everyday event that is humorous in its miniaturization.

One Second Sculpture (1969) was a parallel piece: a metal tape measure removed from its container (like the film pulled from its canister) is thrown into the air, where it springs chaotically outward into a convoluted, floating shape, then falls to the ground as a straight line, as if exhausted by its brief creative outburst. Again the scale is tiny, the object is everyday, and there is no craft or formal intention involved; intentionality is given to the material rather than the artist. Both the film roll and the tape measure have peripheral relevance to the production of artworks, but their presenta-

tion as artworks demystifies and parodies the process. When Yves Klein exhibited the rollers with which he had painted monochromes in place of the pictures themselves (*Untitled Sculpture*, 1956) something similar was involved but imbued with an air of reverent iconicity that Marioni's examples lack—and that is a part of their point. These little works seem to be making fun of the grandiose pretensions to which early Conceptualism was still partly bound by its Modernist roots.

The Act of Drinking Beer with Friends is the Highest Form of Art (1970) was Marioni's first "social" artwork and has become—through the still ongoing Wednesday free-beer salons that keep it alive—a signature work. The genre-term is based on Beuys's "social sculpture," but lightly spoofs its seriousness. After an evening spent in the exhibition space (the Oakland Museum) drinking beer with friends, Marioni left the litter or detritus of the event in place as the art object. A network of cultural and artistic connections suggests itself, both in the tradition of designating detritus as art (especially Arman's *Le Plein*, 1960) and in the tradition of designating convivial occasions as performative events.

Marioni is loyal to his background, honoring, with whatever admixture of irony, the years in Cincinnati at Catholic school, the music conservatory, and the art academy. When he lived past these roots and began making artwork, he continued to acknowledge that level of material. One example is the way Roman Catholic ritualism imbibed in elementary and high school hovers in the background of his later artwork, not unacknowledged or repressed, but slightly tinting the later events with its remembered aura. *The Act of Drinking Beer with Friends*, when viewed in such a framework, may be seen as a sacrament of friends, like the Roman Catholic Communion

rite or one of the earlier instances in the history of religion of communion rites/feasts celebrated in the cults of ancient agricultural gods—beer seems to have been developed around the beginning of the Neolithic Age and was involved in cultic practices associated with the barley crop and its life and death cycle. As Marioni is said to have once remarked, "I am not a big beer drinker, but I am a famous beer drinker." As he and his friends bend their elbows and chat at the Wednesday salons, Hermann Nitsch's OM Theater (1962 and after) lurks darkly in the background, while more recent parallels include the 1970s performances by the California feminist group The Waitresses, James Lee Byars's works in which only red vodka was served, Rirkrit Tiruvanija's gallery meals, and other such works after 1970. The art exhibit as a kind of feast or social sacrament in which life was shared became a part of the expansive art mood of the 1980s and after.

In 1968, around the time Marioni found his way as an artist—as a Conceptual artist in Northern California—he began a parallel and inter-linked activity as a curator. From '68 to '71 he was curator of the Richmond Art Center in Richmond, California, a small town outside Berkeley but still in the Bay Area. This was about the time when the Post-Modernist idea that the curator is in a sense more important than the artist came into effect, especially with Harold Szeeman's show "When Attitude Becomes Form" (1969). The point is that it is the curator who aims the work at society in a certain framework and with a certain agenda. The curator takes over the social trajectory of the work after it leaves the artist's studio, and his ideolo-gy will, if it can, overpower and displace that of the artist. One of the clichés of Post-Modernism in its early decades was that the curator was now the artist, an idea that developed into the Post-Modernist genre of museum

interventionism, practiced by Fred Wilson and others.

Marioni's groundbreaking show at the Richmond Art Center, "Invisible Painting and Sculpture" (1969), involved some immaterial (or "dematerialized") works (his own contribution was two blank pages in the catalogue). The concept was based on Klein, who described his 1958 exhibition of an empty gallery ("Le Vide") as an exhibition of invisible works installed through visualization practices. Other exhibitions involved sly humorous winks toward the canon of art history, like "The Return of Abstract Expressionism" (1969), a sculpture show (!) in which Marioni participated under the pseudonym of Allan Fish. Fish sent instructions for crumpling and throwing pieces of paper into a random array titled *Birds in Flight* (a work that goes back to some of Arp's experiments in randomness in the Dada period). "California Girls" (1971) was a very early feminist show. Dennis Oppenheim (who was still associated with the Bay Area), Bruce Conner, Terry Fox, Howard Fried, and others exhibited there. Marioni's work as curator, as much as his oeuvre as artist, helped to form the new movement and bring it into the open.

In 1970, Marioni founded the Museum of Conceptual Art in San Francisco, which was to be his largest and most ambitious social artwork. This was an early event in what was to be called the New Museology. While Marioni continued to make his own artworks (what he calls the "personal" works), MOCA was, as he described it, "a large scale social work of art." Marioni developed a distinguished history in this role, curating many groundbreaking shows in what has been called the first alternative space. (MOCA's first exhibition opened in April, and 112 Greene Street—often cited as the first—opened six months later in October 1970. F Space in Los

Angeles, along with The Kitchen and P.S. 1 in New York, began the following year.) When P.S. 1 presented the famous show "Rooms" in 1976, in the catalogue the director said, "It is hoped that P.S. 1 will be a prototype for other projects of a similar nature." In fact, Marioni's Museum of Conceptual Art had already been in existence for six years with the same agenda: that of showing works of what was called post-studio art.

Often the exhibitions at MOCA combined Conceptual Installation Art with Performance. In "All Night Sculptures" (1973) artists created works in individual rooms that were open to the public only for one night. Chris Burden, Terry Fox, Paul Kos, and Linda Montano had one-person shows at MOCA very early in their careers. (For Montano's 1973 piece she handcuffed herself to Marioni for three days.) In a 1970 show called "Sound Sculpture As" (possibly the first Sound Art show) Marioni climbed a ladder after drinking beer and, facing the wall, urinated into a bucket below. The changing pitch of the metallic bucket was the sound piece; the rest of the apparatus, including the performer, were the means to produce the piece, just as a projector is necessary to project a film. After fourteen years of such engaged and groundbreaking shows, in 1984 the Museum of Conceptual Art closed.

It was in the early period of MOCA that Marioni began his Wednesday night Free Beer salons, at which, to this day, artists gather, drink together, and converse as social art events. Marioni's signature art-event, *The Act of Drinking Beer with Friends is the Highest Form of Art*, at the Oakland Museum in 1970, was followed by events with titles like *A Social Action* and *Beer Drinking Sonata*. The atmosphere of such events was sociable and humorous, conspicuously lacking in solemnity. At the same time, Marioni pursued his "personal" artworks, chief among them the drum brush drawings.

As early as 1972, Marioni was making these mixtures of drawing, performance, sound art, and chance, and he continues to make them today. Holding the metal brushes that lend to Bebop and cocktail music their cool swishing rhythm, he drums a regular rhythm, right hand circling, left hand punctuating, on some receptive surface, varying from sandpaper to metal to marble. After an hour or an hour and a half the surface contains a drawing—or an impression, or a retextured surface—that is the end-point as object-art. In the early drum brush drawings, done in performance, the sound of the production of the object was for the audience as much a part of the artwork as the ultimate image-object.

Marioni's dual interest in both music and art led him naturally into sound events. He grew up at the moment when the jazz form known as Bebop was at its height; it permeated his consciousness, like that of American Beat culture in general, and the confluence of Bebop and Action Painting was a part of the cultural turmoil out of which his art arose. The use of the metal brushes on the snare drum was a characteristic of Bebop that entered his work and has remained a kind of anchor to it for decades. The drum brush drawings illustrate Marioni's idea that the essence of Conceptual Art is its lack of commitment to any particular medium; the Conceptual artist, like Marioni himself, moves from medium to medium at will, often combining approaches in ways that would have seemed improper in the stricter Modernist period.

In a larger cultural network, the drum brush drawings provoke various associations—the prominence of drumming in some types of so-called primitive music, for example, and the worldwide phenomenon of shamanic solo drumming. The image in Marioni's drum brush drawings is a birdlike form,

suggesting the shaman's invocation of his animal or bird ally, as in the Paleolithic image known commonly as the Bird-man of Lascaux. The drumming summons the bird out of the void. In the West Coast performance tradition, Linda Montano and Pauline Oliveros have done pieces that involved long-term solo drumming as a device to induce a trance-state. Marioni says that his prolonged drumming produces "a semi-hypnotic state for me." The continuous swishing of the brushes functions somewhat like a musical drone or an endlessly repeated riff as in much Asian-influenced Minimal music, such as that of LaMonte Young and Marian Zazeela. Finally, it is relevant to note that the brushes, rather than the sticks, were characteristic of West Coast jazz with its orientation toward the cool rather than the sublime.

From the movements of the brushes, Marioni went on into body drawings, where rhythmic bodily movements with pencil produce an image that is not exactly or explicitly intended but produced by the body's seeking of comfort in its own movement. (Happiness, to paraphrase Aristotle, is when an organism moves in the way it was designed to move.) Starting with *Drawing a Line as Far as I Can Reach* (1972), these works tend to be linked more to mechanical repeated bodily movements than to mental conceptions. In this respect they are related to the so-called blind drawings of William Anastasi and others, in which the drawing grows out of the body's expression of its own nature, more or less bypassing the hand-eye linkage.

In the 1980s, other Marioni works of body movement dealt with heavy themes of the day. In *Studio*, a series continued throughout the decade, Marioni would draw his shadow on a wall-mounted large sheet of paper with a microphone behind it. At the end of the performance, he would move in relation to lights till his shadow merged with the drawn one. A union was

effected in some other world. There is something to this piece that links it with a variety of other pieces, though their moods might differ. Eric Orr, a Southern California artist, for example, once drew his shadow on a piece of paper, took it to Egypt, and burned it in the sarcophagus of the King's Chamber of the Great Pyramid. Frank Uwe Laysiepen ("Ulay") had himself photographed in front of a landscape ten times, each time farther from the camera, till he disappeared into the environment. The three works share a Post-Modernist questioning about the self and how to pinpoint and locate it.

Tom Marioni's early Conceptual work, briefly surveyed here, was instrumental in defining and bringing into visibility the spirit of California in the post-Beat era. As Marioni publishes this memoir he enters another list, jousting with countless authors. A few words will introduce this moment before the reader is left to enter the story himself.

The *Encyclopedia Britannica* distinguishes between the genres of autobiography and memoir. A difference is that anyone can write an autobiography, but "the writer of memoirs is usually a person who has played a distinguished role in history, or who has had the opportunity to observe, at close range, history in the making." Marioni's book thus is a memoir.

An early subtitle of the book was "The Life of a Conceptual Artist in San Francisco," and indeed Marioni's text fills an interesting gap in the record of contemporary art. The encyclopedia article extends its distinction in saying that autobiography is focused on "scrutiny of the self, with outside happenings . . . admitted primarily as they impinge on the consciousness of the subject." A memoir, on the contrary, "is primarily focused on outward happenings." In this respect, also, Marioni's account is as much a memoir as an autobiography. It follows an approach associated with Walter Benjamin—the

individual life-story should be told as embedded in the larger flow of social events, neither as autonomous nor as completely controlled by them. Marioni presents the outlines of his life as interacting with the changing mood of art history as it transpired around him. His life is a part of the social compact of his time, not just a personal recollection.

The question is *why*—why does someone bother to write an account of his or her life? In some cases (like Augustine of Hippo in A.D. 397) the motive seems to involve a desire to control the lives of others hereafter by leaving a testament that involves a judgment on the reader's own behavior. In a case like Benvenuto Cellini's *Vita* (c. 1560), it seems more a celebration of a life experience whose inner power threatens to burst out into high-spirited blossoming in the hereafter. For some others, it seems a desire to see how one's personal life fits into the world around it, as a figure on the larger ground.

I have not asked Tom Marioni about this, so am speculating. My sense is that his motive in putting this record down had several parts. One has to do with art history. I think he wanted to make a statement that would fill a gap in the art historical view of Conceptual Art, to fill in the Northern California side of the story. At the same time he wanted, I think, to retain the simplicity of voice and intention that infuses his artwork.

In this text, Marioni uses mostly simple sentences, so there are relatively few subordinating conjunctions and adverbs involved in introducing sub-clauses. Traditional rhetoric—say the style of the Renaissance humanists—held to a rule laid down by ancient Greek prose authors. Each clause, they said, should contain a word (a particle or adverb or conjunction) that shows its logical relationship to the preceding clause. Is the relationship causal, temporal, adversative, inferential? Marioni instead chooses a child's

rhetoric, which does not involve constant statements and restatements of shifting logical relationships. There are few adverbs, and adjectives are usually factual rather than decorative. Nouns and verbs follow one another like a child's building blocks. Still, there is rarely a sense of ambiguity or uncertainty. A fact is stated after a fact, and the meaning of putting them together comes through with a direct clarity like seeing. In a sense the style is a rhetoric that convinces you nothing is being put over on you. The sculptor becomes a sleight-of-hand artist.

Marioni's memoir is the newest of his social artworks, a work that consists of the author's relationship with you, the readers, not unlike the conversation of friends drinking beer together. In a sense it's a meta-work, since it contains the other works as parts of its content. It represents a step to the next meta-level of combining simplicities. This straightforward memoir counteracts the austere standoffishness of the New York Conceptual artist. It insists that finally art is all real life, or very close to it, and thus accessible to one and all. One has recently heard of the death of Conceptual Art? It is alive and well in Northern California.

PROLOGUE

This is a book for people who don't read. I think you know what I mean. It's a book for artists and interested laypeople, not for academics. It's written in plain English, the way I talk, and it is to the point. I'm writing about what makes someone become an artist, or want to become an artist, and about the world as I see it as an artist, and I'm making an account of some events in my life that influenced me to see the world specifically from the point of view of a sculptor. I think everybody should write a memoir because you get to relive your life without dying after you see it flash before your eyes. I remember seeing Bertrand Russell, an old man with a long white beard, in a TV documentary. He defined happiness as being so busy doing the things you like to do that you don't have time to think about whether you are happy or not.

I have lived in San Francisco since 1959, and I love it and defend it to the rest of the country. It is not a good place for an art career, but it is a good place to live and work. There is no need to worry about the art market because there isn't any. I can criticize San Francisco because I live here; this is not a book published by the chamber of commerce. It is a monologue that sometimes reads like a dialogue. I write to hear how the words sound, but I'm a visual artist first.

I was almost famous one Sunday morning in 1995 when Sam Donaldson, on the "This Week" TV news show, commented on whether or not the National Endowment for the Arts should fund artists. He said the government should not pay for an artist to urinate on stage in front of an audience. That was me he was talking about, only he didn't know it. I did

that in 1970, and I was not funded for it. Donaldson was probably thinking of Andreas Serrano's *Piss Christ*, which had been in the news a lot at that time. It is a large photograph of a crucifix in a jar of yellow liquid that was made in 1989. I did the deed with my back to the audience, up on a ladder, to demonstrate the sound effect of filling a large metal washtub.

In the 1970s art was about using new materials, like using sounds to make sculpture. No painters emerged in the '70s—name one. I know that the painters of the '50s and '60s were still doing good paintings in the '70s, but painting was essentially dead—just like jazz, which had evolved into a fusion of jazz, rock and disco. Urinating in an art gallery is tame by comparison to the shocking performances done by artists in Vienna in the '60s. By now, breaking taboos is commonplace as subject matter for art, and in the theater *The Vagina Monologues*, *Puppetry of the Penis*, and *Urinetown* have entered the mainstream. In 2002, a cartoon in the *New Yorker* showed two dogs walking down the street. One dog says to the other, "What I do as an artist is take an ordinary object—say a lamppost—and by urinating on it transform it into something that is uniquely my own."

In this book I try to define Conceptual Art. Many books have been written on the subject but they are always from the point of view of the author's particular part of the world. For instance, when Italians deal with the art of the late '60s and early '70s the Arte Povera (poor art) movement is what Conceptual Art is about. It is an art of natural materials and theatricality. But if a German author defines Conceptual Art, it probably is from a point of view that demonstrates a scientific principle. The Germans are cool and the Italians are hot. The Conceptual Art movement is an international phenomenon that occurred at the same time in all parts of the world, but took

different forms depending on its location. In England the prehistoric earth-works of stone circles influenced the development of Land Art, and a strong literary tradition influenced Language Art. In New York, Conceptual Art meant Language Art but it was more concrete than Language Art from England. New York also developed Conceptual Art based on systems.

California is a like a separate country. It has no literary tradition except the Beat poets, who were not taken seriously in New York. California is a body culture with influences from Asia and Europe, not so much from New York. The Conceptual Art of L.A. is influenced by the weather and the beach, by Hollywood, Mexico, and Japan. In San Francisco the culture is European and Chinese. I am a product of that tradition.

The Museum of Conceptual Art was my life's work for a decade beginning in 1970, and through it I tried to define Conceptual Art with words and demonstrations. The museum no longer exists, but the social artwork, *Café Society*, that I created in the '70s continues as a forum for art ideas and social drinking. The work I am most known for is *The Act of Drinking Beer with Friends is the Highest Form of Art*, 1970. By the year 2000 this social activity had evolved into an artists' club called the Society of Independent Artists.

Besides art and music, the other important things for me are friends, family, and good weather. Now that I'm a senior citizen, I want good health more than anything. I eat my vegetables, do yoga, and ride my bike to work every day (I don't go up hills). The bike gets me from point A to point B. When I was in China in 1988, a woman said to me, "Do they really have bicycles in America that don't go anywhere?"

Speaking of eating, we are known as "foodies" here. There's a farmers'

market by the bay and every Saturday all the beautiful people show up to promenade. You have to dress to have breakfast at the café on the corner called De Stijl and I cannot reveal the best time to be there because I would ruin it for the regulars. Alice Waters, the inventor of California cuisine, was one of the founders of the market and she is usually at the café on Saturdays along with the symphony conductor, and quite a few restaurant owners, filmmakers, and artists. There is often a news crew from Germany or France filming the food. Famous chefs are giving lectures and cooking demonstrations. When tomatoes are in season, tastings are offered. Some people arrive in chauffeured limousines. By two in the afternoon the whole show is gone and a vacant parking lot has appeared.

We now have a wine section in addition to the food section in the *San Francisco Chronicle* and there is also a food gossip columnist. New York is the center for art but San Francisco is the center for food. Food is our art. The paper has three food critics and only one art critic. Sometimes I think I'm in the wrong business. But if you want to live in all this beauty, you adjust and find meaning in arugula.

We are so liberal and democratic here that most public art never gets approved. The public writes letters to the editor complaining about a picture in the paper of a proposed public sculpture or new building, and the board of supervisors nixes the project. When a sketch by Claes Oldenburg appeared in the paper of a Cupid's bow and arrow sculpture, the wheelchair police said it was not accessible, and Native Americans said that an arrow sticking in the ground means war in their culture. The sculpture was realized, but only because it was privately funded and placed in a park paid for by Donald Fisher in front of his new Gap headquarters building. The city

allowed the building to exceed the height limit in exchange for financing the park. Now that the sculpture is in place, it is too late for the public to do anything about it—but they are writing letters to the newspaper anyway. When a Picasso sculpture went up in 1967 in Chicago, people made fun of it, but in time they were proud of their "Chicago Picasso" because it had become familiar. In one part of this book, I write a list of dos and don'ts for public sculpture including "Be controversial at first" and "Become a thing of pride to the public."

Some of the ideas in this book were new thirty years ago, and are familiar now. They have entered the world as neo-Conceptual artworks that use the materials and have the look of Conceptual works, but are based on reused ideas, like retro fashion. Since about 1980 we have been in a "neo" period. I believe the best art records society in a poetic way, and in order to do that, I hope the next art will have its own presence.

Cincinnati, 1949

When I visited a temple in Bombay, India, in 2001, it reminded me of my childhood in Cincinnati being an altar boy. In the temple, people were ringing bells, there was incense burning, men were grinding sandalwood to make soap, and people in white robes were walking around. It was kind of theatrical, but I remember the Catholic mass was kind of theatrical too.

In 1949 when I was in the sixth grade I was an altar boy, and I had to learn some Latin to say the prayers that answered the priest. There were two altar boys and I was the bell ringer of the two. Six bells were in a row on a rod, so when I shook them I rang all six at once; since they were all the same size they were not musical. Everything went together: the bells, the incense, the foreign language, and the costumes, all part of a ritual that is more than a thousand years old and still being done the same way.

The celebration of the mass is a symbolic re-creation of the Last Supper with the priest filling in for Jesus. At the Last Supper, Jesus broke bread and they had wine. The bread and wine were the basis of the meal. In the Catholic mass, the bread is given to the people in the form of a host, but the priest drinks the wine. In some Protestant religions wine is given to the congregation in little cups, but in the Catholic Church the priest drinks the wine at the altar with his back turned to the parishioners while an altar boy waves burning incense. The idea is to intoxicate the people with the incense. Long ago, people probably drank the wine and became intoxicated as a way to heighten the experience. In other religions, smoking a peace pipe, eating mushrooms, or drinking an intoxicating drink gets people in a state of mind that makes them more open to spiritual enlightenment. The

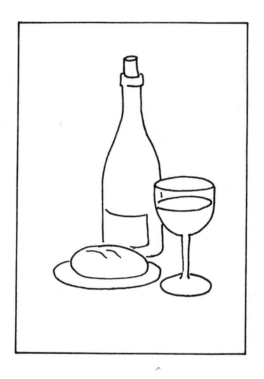

BREAD AND WINE

Holy Rollers get themselves into a frenzy in order to heighten the experience of the ritual. Chanting and gospel singing do the same thing.

This didn't occur to me at the time because I was twelve years old, and I learned the routine and followed it through just like playing a part in a play. It was my job as altar boy to light the candles on the altar. I used a long stick with a wick on one end, and after the mass I used a little cup on the other side of the wick to put them out. The priest was wearing a dress and so were the altar boys because those were the vestments they wore in the old days.

The priest went up to the altar and turned his back on the audience.

These are things that fascinated me later, when I began making perform-ance art. It was the idea of the priest doing something you can't see. It's all a matter of faith. You know the ritual, the routine, so you know he's drinking the wine and breaking the bread and taking the host out of the little chalice on the altar. The chalice is in a small safe that has a little curtain in front of it, with lace on the bottom, like a woman's slip. The curtain has a slit in the middle of it and the priest sticks his hand right into that slit holding a little key that he takes out of his pocket. It's even on a key chain. He puts the key in the lock and unlocks the little metal door, and then he reaches in the door with his hand up under this skirt and he pulls out a beautiful polished gold chalice—sometimes it has jewels on it. In it is the host, the body of Christ. After reaching up under the white lace slip, the priest pulls out Jesus.

The host is made up of little round wafers of bread; it's bread that doesn't rise, unleavened bread. Each one of those wafers is a slice, almost like a slice from a sausage. People come up to a rail and kneel down in front of the priest who takes these pieces out of the chalice, one by one. People stick their tongues out and he lays the host on the tongue of each person. At the same moment he says, "the body of Christ." And the altar boy holds a little gold saucer under your chin that reflects light on your face.

The priest sticks the host in your mouth. You can see light through it. When I was a kid, we used to play communion with flat round candies called Neco Wafers that came in pastel colors. You're not supposed to chew the host because it's not supposed to touch your teeth. That would be a venal sin. You just hold it against the roof of your mouth and it dissolves enough that you can swallow it without chewing. The priest moves along to

the right and then more people come up and kneel down. You go back to your seat and you kneel and say a prayer. You've received the body of Christ. That was Holy Communion.

Once a year, you got your throat blessed with an instrument that curved around your neck and had a candle attached to it—you looked right at the burning candle inches from your face. This was so you wouldn't choke on a fish bone for the rest of the year. You ate fish every Friday. I was always afraid that if I didn't have my throat blessed, I would choke on a fish bone. Since I moved to San Francisco, I've learned to like fish, but I'm still worried about choking on a bone.

At mass there were two little cruets with wine and water that the priest would mix in the chalice to change it into the blood of Christ, and he would drink that as part of the ceremony. My favorite story from the New

CHALICE

Testament is about Jesus coming late to a wedding reception. The bride's father tells him, "We have been waiting for you. We are almost out of wine." And Jesus says, "Fill these jars with water and bring them to me." When they are filled, Jesus changes the water into wine, and after the guests start to drink again, someone says, "Why did you wait until everyone drank freely before serving the good wine?" Of course, it's no more work for the Lord to make good wine than cheap wine.

The candles, bells, bread, and wine; the gold chalice, the little safe, the candle snuffer—those were all objects that had power because they were used, they had a function, and they were sexually suggestive. I wanted to make objects with that kind of power. That's why I became a sculptor.

In the late '70s, I designed a kind of ritual performance called *Studio*. My idea was to re-create the look and mood of an artist's studio in a public

STUDIO PERFORMANCE

space, then celebrate the act of making art. I stood up in front with my back to the audience, drawing my shadow with a long pencil on a very large piece of paper. A microphone behind the paper amplified the rhythmic back-and forth-sound of the pencil; the light was dramatic and the sound repetitive. When the drawing was finished, I stepped back and looked at it, then poured a beer into a wineglass and drank it. Lights were set up on each side at the back, with a narrow curtain in the center of the room. After drinking, I slowly backed up to the curtain, and my shadow looked as if it disappeared into the paper.

I did this performance first in 1980 in the Kunstmuseum in Bern, Switzerland, and repeated it, changing some details, in other places during the early '80s: at the University Art Museum, Berkeley, in 1980, and in a festival in Berlin called "For Eyes and Ears" in 1981, for example. During that period I also made shows in Bologna, Basel, Boston, Belgrade, Bozeman, and Bisbee. If I ever needed a short bio for a catalogue, I would only list the work I did in cities that began with B. At the end of the list I would write, "and that's just the B's."

The Catholic grade school I went to in Cincinnati was called Summit Country Day School. When I started first grade, the Second World War was still on. Summit was an all-boys school. For the first three years I had nuns for teachers, and after that male teachers who were laypeople. The monsignor came in to teach classes in religion. I took a streetcar to school every day from the time I was seven years old. In San Francisco, fifty years later, I can ride the same streetcar down Market Street. San Francisco has purchased and refinished old streetcars from other cities around the world, including Cincinnati, as a tourist attraction,

The Catholic Church inspired me, but it also made me a skeptical person and made me question authority. In 1946, when I was in the third grade (), a nun told me that in 1953 there would be three days of darkness and all the evil people would be struck down dead. I was sure the church was lying about everything when 1953 came and nothing happened.

In the early '80s the Shroud of Turin was carbon-dated, and instead of being two thousand years old, it was less than a thousand years old. It was supposed to be the burial cloth of Christ, covered with blood that left an impression of his face and body. The Shroud of Turin is an illusion with the power to become something that it isn't. In that way, it's a work of art even though the artist is not given credit.

Rorschach's inkblot test is like that too. It wasn't intended to be a work of art, but it has the characteristics of art. Rorschach did watercolors and blotted them, thousands of them, then chose ten and assigned a meaning to each one. For instance, Number Seven represents Woman. When you're given the inkblot test, whatever you see in Number Seven is

RORSCHACH TEST

interpreted by the psychologist as your idea about women.

In 1978, in San Francisco, a psychologist from Canada looked me up when she was in town. She had written a book on architects based on their reactions to the Rorschach test, and was planning to do one on artists. She gave me the test. That's how I learned about the cards. When I looked at the cards, I immediately turned them over to see the backside and find out where they were printed. I asked about their thickness and why the corners were rounded and what kind of paper they were on. The first five of the ten cards were in black and white, and the last five in color, and I asked about that, too.

I was so fascinated with the mechanics that I was frustrating her. I was supposed to see spiders and vaginas in the cards, but I wasn't interested in trying to interpret the images. I was interested in how the cards were produced and how Rorschach made the images. She never did her book, probably because it is impossible to do a Rorschach test on artists. She should have done it on art critics instead. They could see the images, interpret them, and then criticize them. That should have been the book.

I asked her where I could get ahold of a pack of those cards. "Oh, you have to be a psychiatrist or a psychologist to get them," she said. "You could never get them." I told her I wanted to make an exhibition of them at Breen's Bar, where we were having a drink at the time. She said, "Oh no, you could never do that." At that time they had never been reproduced in a book. "If the images became familiar," she said, "people wouldn't be spontaneous when they interpret them. It would ruin the whole effect."

One time the bishop came to visit our school. We all went up and knelt down and kissed his ring. He was holding a tiny box with a glass window in

it, and inside was a relic of the True Cross. Only it wasn't a first-class relic; it was a second-class relic. A second-class relic is a piece of wood that touched the real cross. So how many generations can you continue that? Could you have a piece of wood that touched the wood that touched the cross? That would be a third-class relic I guess.

What I learned about first- and second-class relics in grade school later influenced my art, especially my sculpture documentation. What is the real thing, what is a facsimile of the real thing, and so on? For me, a first-class relic of a performance would be a drawing created while making the art action. The drawing of my shadow in the *Studio* performance would be a first-class relic. A second-class relic would be a photograph of the action. In a way, the bishop's second-class relic of the True Cross was a facsimile. It's all about faith anyway.

The last Wednesday of every month, everyone in the school went to the chapel for Benediction, which was a ritual ceremony with prayers. I didn't connect this to my art at first, but for the past thirty years I have been having meetings once a week with other artists, drinking beer and talking, and the meetings have always been on Wednesday. Benediction probably had something to do with that. Drinking beer with friends is a kind of ritual experience for me.

When I was in grade school, I learned to repress impure thoughts. Once a month we would have a dance. The girls came from the girls' school, which was separate from the boys'. If you went to classes with girls, you might accidentally brush up against one of them and have an impure thought. Or you might look at her patent leather shoes and see her panties under her skirt. The girls weren't supposed to wear patent leather shoes for

that reason, because they might reflect what was up their skirts. Everybody who went to Catholic school in the '50s knows about that idea.

We would have dances, tea dances with dance cards. You would ask the girls to dance in advance until your card was filled up, then dance to music on a record player while the nuns stood off to the side and watched to make sure you didn't dance too close.

We learned the art of self-defense: boxing. I was real skinny and matches were determined by weight, like in professional boxing. I was a lightweight or maybe even a featherweight. When I was in the eighth grade, I had to go into the boxing ring against a fat sixth-grader who was a foot shorter than I was. It was embarrassing. Of course I won the match. His arms weren't even long enough to reach me, but he weighed the same as me. That was a flaw in the system.

We were all Catholic kids except one kid, Larry Patterson, whose father was a Chrysler dealer. Because he wasn't Catholic, he didn't have to go to religion class. He could go off by himself and play or read or something. I was always jealous of him because he got out of one class and he could eat hamburgers on Friday. Most of the kids were German because Cincinnati was a German beer town. They had names like Kitzmiller, Wesendorf, or Weiskettle. I was in a minority with an Italian name.

My father was a medical doctor whose patients were mostly Italian immigrants. He had a library at home, and he used to write and paint on Sunday. He was a cultured man. He came to this country from Italy in 1921 when he was twenty-one and worked his way through medical school

MILK

by making ice cream. He was born in London at the turn of the century, but the family moved back to Italy when he was two. His father was an ice-cream man in London and then also in Italy. My father never ate chocolate ice cream because, he said, they make it by putting old milk, cream, and even cottage cheese together and covering it up with lots of chocolate.

My father's brother also made ice cream. He became an architect. His name was Luigi and he was maybe the first modern architect in Cincinnati. He designed ranch-style houses influenced by Frank Lloyd Wright. He let me draw with his T squares and triangles when I was a kid and I thought I wanted to be an architect. After I saw a picture of Wright's 1935 Falling-water at my uncle's, I spent years drawing houses sticking out over the edges of cliffs.

We were a dairy family. My mother's mother started a dairy store in Syracuse, New York, in the front room of her house, selling milk, butter, and cheese that she bought from farmers. Later it became a big business.

They bought milk in bulk and bottled it in a plant, then delivered it to homes in milk trucks. My grandfather never worked in the dairy. He worked in a factory and retired early. They were married when my grandmother was sixteen and had twelve children. My Uncle Tommy was my mother's uncle who married my father's sister. So my mother's sister-in-law was also her aunt, and their children were my first cousins on my father's side and my second cousins on my mother's side. It was like that song that was popular in the '50s called "I'm My Own Grandpa."

My cousin Pat took me to the wrestling matches when I was a kid. He was the referee. I could never get him to admit that the matches were faked. In those days many people, like my Aunt Fanny, believed the fights were real. But any twelve-year-old could see that it was theater. I saw Gorgeous George fight in Cincinnati when I was twelve. Dave Hickey, in his book *Air Guitar*, said that Liberace with his outlandish costumes influenced Elvis Presley and the Rolling Stones. I think Gorgeous George, who wore sequined robes and had long hair held by gold-plated bobby pins, influenced Liberace.

We lived in a red brick house on the corner of Delta Avenue and Observatory Road. The observatory up the hill was open once a year to the public for viewing the moon. It was built in the nineteenth century, so it was obsolete by the time I was able to visit it, but it left a lasting impression on me. In 1988, I was able to make a public sculpture for the grounds of the Marin County Civic Center, in California. The civic center was the last building Frank Lloyd Wright designed, and I always thought it looked like an observatory. My sculpture is a mound with a working telescope on top. I called it *Observatory Bird*.

Two doors down from our house lived Dr. Hinnen, the curator of the Cincinnati Zoo. His front yard was covered with vines. Every house on Delta Avenue had a green lawn in front except his, because Dr. Hinnen didn't believe in killing any living thing, not even grass. My brothers and I would sneak into his backyard so we could see the monkeys swinging from bars in his breakfast room. Dr. Hinnen would take the streetcar to work with a big snake around his neck. He would always tip his hat to my mother if we were sitting on the front porch when he was coming home from work. We just thought that's what zoo curators were like.

Tommy Earls, my friend who lived two houses away had a TV in 1948. That was the year Milton Berle's *Texaco Comedy Hour* began. Once I was invited over to watch the comedy hour at eight p.m. with Tommy's family on a Tuesday night. Their TV looked just like my Dad's big radio except it had a small screen where the lighted dials should have been. We were the last family of all the kids in my school to get a TV. I would sit and look at the radio and make up pictures in my head. Jack Benny's show was my favorite. Sometimes you would hear him leave his house and walk down the sidewalk and cross over to the house of his neighbor, Phil Harris, and go up the walk to the front door and ring the doorbell. It took about two minutes of airtime with no dialogue, just footsteps, but I could see it all.

We had a Steinway baby grand piano that my mother played. My mother sang opera around the house and also sang with choral groups. She didn't sing professionally. She also played the harp. I used her tuning wrench to tighten my roller skates. We had a lot of music around the house.

My brother Don and my brother Joe both took piano lessons. My brother Paul took two lessons on the trumpet, but he didn't like it and our parents

didn't make him pursue music any further. Every Saturday my father drove me to the Conservatory of Music to take my violin lesson. On the way we listened on the car radio to a nationally broadcast program from Cincinnati called *Big John and Sparkie*. John Arthur, who produced the show, owned a record store on the street where we lived (I bought records from him). He invented a technique of speeding up the recording of his voice so that he could create a convincing voice of a chipmunk. The radio show was made up of conversations between John Arthur as Big John and his chipmunk-self, Sparkie. It was created entirely on tape and made me aware of tape-recorded sound.

My father would drop me off at the conservatory and go on to his office. A violinist from the Cincinnati Symphony, Carlo Mastropolo, was my teacher. He also formed a youth orchestra that I played in. I was in the second violin section, and I found out that the best way to listen to an orchestra is to be sitting in the middle of it.

As I walked down the hall to my lesson room, I liked noticing the different sounds coming from the practice rooms. One room would have an opera singer, another a trumpet player, another a piano. It was like pieces of the orchestra broken up. In 1991, when I was invited to make a radio piece for WDR public radio in Cologne, Germany, I remembered that experience in the conservatory. I assembled all my recorded Sound Art works from 1969 to 1991, then recorded my footsteps. I edited the footsteps to fall between the different works and created a thirty-minute tape. It sounds as though I am walking down a hall opening doors and listening for a minute or two at each one.

Don is my oldest brother, four years older than me. When my father wanted to call one of us he would always start with Don, then go to me,

Paul, and Joe, in the order we were born, stopping at the name he wanted. In high school, Don was a playboy. He wore sharp clothes and went out with fast girls and was in a fraternity. He had skipped a grade in grade school, so he graduated from high school when he was only sixteen, got a scholarship to MIT, and flunked out after the first semester. Later he went to Stanford and became an aeronautical engineer, a real rocket scientist, and retired at fifty five. He lived in the Stanford area for a long time, then moved to Seattle. Don's wife, Gail, is from Washington State, and they decided to retire there.

Don told me he went to hear Art Tatum play piano in Kentucky and afterward asked him for his autograph. Art Tatum was standing outside smoking a cigarette, and he pulled out a little stamp and a stamp pad from his pocket, and stamped his autograph on a piece of paper. It said: "Musically Yours, Art Tatum." Tatum was blind in one eye and almost blind in the other one. I guess the stamp was his solution to the autograph problem.

Paul is four years younger than me. When he was a little kid, he thought about being a priest. He graduated from the University of Cincinnati, where he studied philosophy, English literature, and poetry. He followed me to San Francisco. I followed Don and then Paul followed me, and then Joe followed Paul. Joe moved on to New York after he was here a few years. Paul stayed here for about twenty years and then moved to Seattle. Paul, Joe, and I all became artists, and we ended up in the cities that were right for what we did. Paul is a glassblower. He and his girlfriend, Ann Troutner, make cast-glass sculptured walls for public spaces and create other public art projects using glass. Seattle is where Paul should live, because that's the center for glass and crafts. Joe is a painter. He should live in the art marketplace, New

York. I'm a Conceptual artist, and I should live in San Francisco because it's a place for social experiments, and it's laid-back. "Leisure is necessary to wisdom." Plato said that.

My generation had a romantic idea about the life of an artist, but our children have no illusions about that. Paul's son, Dante, is an expert glass-blower, and he says he is not interested in being a "glass artist," but in "the art of glass blowing." Dante's work is in the collection of the White House. He went to dinner there and was photographed with Hillary and Bill Clinton. He gave my mother a copy of the picture of him, and she hung it in her living room. At that point, she became a Democrat. Later, she took the picture down. But she's still a Democrat.

Joe is my youngest brother, six years younger than me. We were not very close until we were adults and both became artists. While Joe was a graduate student at the San Francisco Art Institute, we shared a studio above a pawnshop on Third Street and Minna, where the San Francisco Museum of Modern Art is now. He moved to New York after he graduated.

Joe was a stripe painter in graduate school and then in the early '70s he became a monochrome painter. His paintings look like they are still wet and the paint is running down the canvas; that's what separates them from most one-color paintings. They don't look dead. Joe is considered a theorist of the monochrome painting movement. When he was in high school he was in a chess club, and at night he would play our dad and win. It frustrated Dad because Joe, like me, was not a good student. My father could not figure out why he couldn't beat Joe at chess because chess is an intellectual activity. He assumed that if Joe wasn't good in school he couldn't be intellectual.

Two of the smartest men of the twentieth century, John Cage and Marcel Duchamp, used to play chess together. I was lucky enough to know Cage, and he told me that Duchamp once got mad at him and said, "You don't care if you win or not!" Cage said that it was true: chess just gave him a chance to be with Duchamp. Duchamp thought that chess was sculpture created in your head. You have to construct your moves in your head before making them.

Joe was not particularly interested in music. He played piano, but he learned basically only one song that he used to play over and over. He would drive all of us crazy playing it every day. But Don played the music of Fats Waller, James P. Johnson, and the stride piano players. I played the violin through grade school and high school, but not after that. To me the violin is sometimes a symbol for the female form, like the guitar was for Picasso, and sometimes it's a symbol of nineteenth-century symphonic music, which stands for the Old World, the past.

I have used the violin occasionally in my art. In 1979 when I was in Vienna, where Freud was born, I realized that it has a backward-looking culture, looking to the nineteenth century, and I did a Freudian installation called *The Power of Suggestion.* I hung an enema bag filled with water on the wall and connected it to a violin, which was hanging by a wire from the ceiling. A yellow lightbulb illuminated the objects. The shadow of the violin on the wall was bathed in yellow light reflected from a piece of mirror on the floor under the violin. I remembered something Duchamp said about Europe, that it needed an enema.

I grew up in a very European household, where everything was from the old country: Dante and Leonardo and Puccini. But my brothers and I were

CHESS

most interested in things that were American, like jazz, airplanes, and cars.

Don was interested in airplanes. He used to build models from kits, and they were hanging all over the room we shared. He had wires running across the ceiling, and hanging down from them were different kinds of World War II fighter planes and bombers.

I was interested in cars, but there were no kits for cars, so I built model hot rods from scratch out of balsa wood and painted them. The best hot rods were 1932 Model A Fords. When I was in high school, the most popular car to make into hot rods were the Ford convertible, three-window coupe, and five-window coupe. The three-window coupe was ideal. Take the

MODEL AIRPLANES

fenders off and lower the body, chop it, and channel it so it sits lower to the ground, and put little motorcycle fenders on the front wheels, sometimes no fenders on the back wheels. You need fenders on the front wheels, because otherwise when you turn a corner, the wheels will throw dirt up on your windshield.

There was also a custom car culture where the cars were sculpted as opposed to being stripped down. Back in the '40s, there was a guy in Hollywood named George Barris who customized cars, and later made eccentric cars like the Batmobile for the TV show. Before 1955, most of the cars that were customized were Fords. In the '40s and early '50s, before fiberglass was invented, custom car builders used lead. They had a tool that was something like a wood-burning tool, or a small iron. They would take thin strips of lead, lay them on the seams of the car, and rub the hot iron over the lead,

and it would melt. They would smooth it, to fill in the cracks and make the car more round, almost as if a nylon stocking had been stretched over the whole car to give it a seamless look. Then they would file and sand the lead areas and paint the car black. Those custom cars were referred to as lead barges.

I was a car buff during the transition period between lead and fiberglass. My brother Paul also got into customizing cars. Later he became a body man and worked for years in a car body shop before he got interested in glass art.

The main point of customizing a car was that it should be seamless. You would fill in the headlight rims and replace the bulbs from inside rather than from the front. These were called Frenched headlights. When you put covers over the real wheels, your car had skirts. When you took the door handles off and filled in the holes, you usually had a hidden button underneath the car to open the driver's-side door. You would also take off the trunk handle, the hood ornament, and the chrome strips. But sometimes you'd have one chrome strip, just a little bit of chrome so the car wouldn't be completely devoid of it. That was called shaving the car.

If you also had the rear end lowered, you could have a car that was Frenched, shaved, and lowered. You might have a special differential in the back, called a 311 Rear End. *Channeled* meant that you moved the body down lower on the frame. *Sectioned* meant that you had cut a section lengthwise out of the middle of the car and put the body back together so it was thinner. You ended up with a car that looked like a sports car. When '49 Fords were sectioned, they looked like the 1954 Thunderbird, the first Thunderbird. Ford got the idea for its sports car from custom cars.

Chevrolet made the first Corvette sports car in 1953. That was the beginning of Chevrolet taking over from Ford as the cool car to have. In the '50s, if you read the custom car magazines, you could predict what the cars of the future would look like.

Except for "laying rubber" on the street and "squealing out," custom cars weren't for drag racing. They were just for show. They were for picking up girls—that's what it was about. In the '60s a lowrider culture developed in the Latino community in L.A. It was similar to the custom car culture of the early '50s. The Latino lowriders are designed to dance, to attract girls. They have a motorized spring that makes the cars bounce up and down, just like a peacock doing a dance to attract a mate. In the '50s, cars were lowered in the back so they would look as if they were accelerating fast. In the '60s, cars began to be lowered in the front for wind resistance, which made them look as if they were coming to a sudden stop.

Custom cars always had mirrored finishes. You would spray lacquer and then sand the surface with fine sandpaper and water, until it got dull and smooth. Then you'd do another coat. Some cars had twenty-five coats of hand-rubbed lacquer. The last three or four coats were clear. The final coat was polished with rubbing compound, which made it very shiny. In the end, the custom car was a sculpture that surrounded you.

Every summer our family took the train to Syracuse, New York, where my mother's family lived. That's where my grandmother had her dairy. I could walk in anytime and take out a small bottle of chocolate milk from the giant refrigerator. Uncle Tony Ross had a bakery, and I could have all

the glazed donuts I wanted. Another Uncle Tony, Uncle Tony Geiss, took me to a farm at five o'clock one morning in the dairy flatbed truck to pick up large cans of milk from the farmer. We stopped at a truck stop and I had my first cup of coffee.

When we left for vacation, we had a cat problem. We always had cats in our family. They didn't need much care, just feeding, and they were fun to pet. One of our cats even gave birth to kittens at the foot of my bed; that's how confident she was living in my bedroom. I put her kittens in the bottom drawer of my dresser with the drawer open just enough for her to come and go. All our cats were called Kitty. We got them from the cat orphanage, the SPCA. When it was time to go on vacation, we couldn't take the cat with us, so we took it back to the SPCA to be adopted by another family. When we got back from our vacation, we adopted another cat. Over the years we had every color, age, size, sex, and brand of cat. We always came to love the new cat in a few days as most cats have the same personality. Once we got a cat that could climb down a tree backward; that was a smart cat. Most of our cats would get stuck up a tree if a dog chased them, and we would have to tie a basket of food to a long stick in order to coax them down.

Uncle Tony Ross had a speedboat that he let me drive once. We spent most of our vacations by Oneida Lake at my grandparents' summer cottage or at Uncle Tony's cottage on the other side of the lake. I liked my two Uncle Tonys. Their last names had been Di Geissi and Rossi in the old country, but names were often changed in those days, for convenience or by accident. When Italian immigrants got off the boat at Ellis Island the customs inspectors wrote on some of their coats in white chalk TO NY—"to

New York." My son Tony told me that joke. He is named after both my Uncle Tonys.

One of my father's best friends, Harry Gothard, was a professional mural and portrait painter. He painted the murals in the Cincinnati airport and was an influence on me. When you're a kid and you know a serious artist, or you know a serious astronomer or a serious anything, you feel that you have some kind of firsthand connection to that field.

When I was in the sixth grade, a new hotel was built in Cincinnati. It was called the Terrace Plaza Hotel. In winter, there was an ice-skating rink on the roof, but it was small, a little balcony that stuck off the side of the building. This was in 1948. The hotel had two great restaurants and one of them was a famous four-star restaurant called the Gourmet Room. The Gourmet Room was round and up on top of the hotel. Half the room was glass that overlooked downtown and the rest of the city. The side of the restaurant that wasn't glass had a large curved mural by Miró that the hotel had commissioned.

I found out fairly recently how the mural came about. Marcel Duchamp's wife, Teeny, was from Cincinnati. Her father was a doctor. She was first married to Pierre Matisse, who was an art dealer in New York and the son of the famous painter Henri Matisse. Pierre Matisse was the dealer who got all the art commissioned for the Terrace Plaza Hotel. Because Teeny later married Duchamp, I have a Cincinnati connection from my childhood to him.

My class went to see the new hotel. It was the first modern skyscraper in Cincinnati. Although the restaurant on top was partly glass and the guest rooms had windows, the bottom part was offices and a department store, and the lower floors were without glass. From the ground, the building seemed to

be all brick, a brick box. That was very modern. It had no ornamentation.

The Miro mural was painted on canvas and glued to the wall. Miró painted it in New York. I looked at it, and I thought, This guy is really getting away with something. That was another seed that made me want to be an artist. At that time, I liked to draw, especially cars. Most kids drew airplanes shooting at other airplanes—airplanes are easier to draw than cars. They don't have wheels or windows that are very visible.

I went back to the hotel in 1996 and ate in its restaurant. My wife, Kathan Brown, was with me and I wanted to show it to her. When I lived in Cincinnati, this restaurant had a famous French chef and was written up in *Life*. My family never ate there because dinner cost twenty-five dollars in 1948. That would translate into hundreds of dollars today, but Kathan and I both had dinner for twenty-five dollars. It was not a gourmet restaurant anymore. The décor is not elegant. They had hung chandeliers and put in gaudy fake leather furniture. And they had taken out the Miró, which is now in the Cincinnati Art Museum. All the other art was also gone. When the hotel was new, Alexander Calder had a mobile in the lobby, and Saul Steinberg had painted a mural in the second of the two restaurants.

Steinberg is the guy who did the famous cartoon of America called *View of the World from Ninth Avenue*. He showed the streets of New York, then New Jersey, then a big area called the Midwest, and finally the West, with one cactus. It's very funny. It's very telling. It's a real New Yorker's version of the rest of the country. When I go to New York, sometimes I say to my friends, "I thought I'd visit the Coast." They're thinking, You don't visit the Coast, you come to the Center of the Universe.

Hotrods, 1951

I started high school in 1951 and took art classes for all four years. One time we were given an assignment to paint a portrait of another student in the class. I painted Ben Duke, one of six black students in our school of eight hundred students. I didn't know at the time that I was color-blind, and I painted him green. After that, I always read the name of the color on the paint tube.

I played in the school band, but because I played violin, I was not in the football marching band. I also played in George Nagley's dance band. The girls didn't go for violin players. I knew I should have been a drummer at that point. I did become a drummer much later. In 1973 I formed a jazz group. I played conga drum or an old rusted piece of steel. When we played at the Institute of Contemporary Arts in London, a girl told us afterward that our music made her wet her pants.

In high school I had a girlfriend with red hair, and when we went out on a date she had rules about feeling her up. If we went to a formal dance, I could feel her up, but if it was just a movie I couldn't touch her. If you planned to feel up your girlfriend, you had already committed a sin, so you might as well go ahead and feel her up if you could get away with it. The priest who taught our religion class said that holding a kiss for longer than a second was a sin. He had a sense of humor, though. When a boy in the class asked him if it was a sin to have sex with a dead woman, he said he didn't think it would be very much fun.

One of my father's patients was a tailor who paid his bill by making suits for my brother Don and me. Although Don had always been a sharp

dresser in high school, he was in college by this time and had become more conservative. I was a junior in high school, and I ordered a charcoal gray flannel suit, continental style with very small lapels and double flaps in the back. The pants were pegged to fourteen inches. They had hidden belt tunnels, and the back pockets had upturned flaps with hidden snaps. I always wore a Mister B shirt and a thin tie with this suit. The Mister B shirt was invented by Billy Eckstine, the singer and jazz orchestra leader of the '40s. The shirt had a big collar that curved up and down to make a tunnel for the tie. Dean Martin wore one. I thought these were really fine threads.

After I got to art school, I wore Levi's jeans all the time for the next thirty years, jeans with a white shirt and sports coat. I was glad to see a picture of Andy Warhol in the late '60s wearing the same artist's uniform I was wearing. Of course, in the early '60s I was trying to dress like Miles Davis. Sometime in the '80s the artist's uniform changed from jeans to all-black clothes. I learned that photographers wore black when they were shooting in the studio so they would not reflect light onto the subject, and then they began wearing their black clothes on the street and artists began dressing that way too. Jeans were no longer the artist's clothing of choice. In San Francisco two of the richest families and the most important art collectors are in the clothing business: Levi Strauss and the Gap. The Gap took over when people stopped wearing blue jeans, especially when khakis became popular sometime in the 1990s.

When I was fifteen, in 1952, my parents took us on vacation by train to California on a tour. In San Francisco, we stayed in a hotel at the bottom of Chinatown, and I walked up Grant Avenue, went into a shop, and looked into one of those little eyepieces where you see a naked woman. The next

night we went on a nightclub tour. Bimbo's had an act with a topless woman in a fish tank. She had a fish tail like a real mermaid. This act had been written up in *Life* Magazine. The Hungry i had just opened. It had folksingers and sawdust on the floor. I thought that the best show was walking down Jackson Street to see the Barbary Coast district in North Beach with blinking lights that said "Girls 50 Girls." Fifty cancan dancers. I could see inside the door. That's when I knew I wanted to live in San Francisco.

1955

My first day at the Cincinnati Art Academy was like my first day at kindergarten. I was nervous about being with new people. I registered, and got my art supplies from the supply store. I was told to report to a drawing class where the whole school met at 8:30 a.m. to draw quick five-minute sketches from a live model. With no warning, I walked into the classroom, and up on a stand in the middle of the large room was a nude, naked lady, with no clothes on, posing in a room full of forty or fifty people. She even had her legs spread apart and I could see everything. This was the first time I had ever seen a nude woman. As I was drawing her, I got excited and could not get up to leave the room at the end of class. This was called a warm-up class. The art academy emphasized drawing as the foundation of all art. I thought I had died and gone to heaven.

There was no dress code; everyone was an individual. At lunchtime I was standing at the front door and up the long driveway came a black 1950 Jaguar XK 120 coupe. It pulled up to the curb and a man wearing all-black clothes got out. He had a mustache and goatee, and someone told me he graduated last year and had came back to visit. I thought, Someday that

MODEL

will be me. Then another car drove up. This car was a big black hearse and a girl about my age dressed in all-black with long dirty-looking hair and a big nose, right out of the Adams family, came walking up the sidewalk. She was a printmaking student and made small, tight, scratchy etchings in printmaking class.

There was a beautiful girl in my class who, I was told, had had a nose job. Tom Wesselman, the Pop artist, was in my class. He had been in the army and had studied at the University of Cincinnati. He was seven years older than me and was already having his cartoons published in *Esquire*.

Two other friends of mine were ex-servicemen; Jack (Sneak) Schneider had been in the marines and Paul Jorling had been in the navy. They were all on the GI Bill. Paul Jorling told us he never bought a car that cost more than fifty dollars. He said that if his car didn't start someday, and he didn't know if someone had shoved a potato up its exhaust pipe, it wouldn't matter. He could just leave the car and buy another fifty-dollar car.

Carol Muckenfuss became my first girlfriend at art school. The sculpture teacher, Chuck Cuttler, used to refer to her as Carol Mustn'tfucker. When she graduated four years later I think she became an airline stewardess. The sculpture teacher was a stone carver famous in the Midwest. He was the classic bohemian artist. When he bought a new Ford truck, the first thing he did was glue a piece of sandpaper to his dashboard so he could strike his matches on it. I had become friends with the ex-GIs and used to go with them up to Frank's bar in the afternoon and drink draft beer for ten cents a glass. Chuck Cuttler was there every day. He was more a role model than a teacher in the traditional sense.

The printmaking teacher, Mr. Hellwig, wore a tweed jacket with a red shirt and a bright-colored tie. He had wavy hair and a Dalí mustache. Mr. Chidlaw, my painting teacher, had white hair and looked like Monet. He painted like him too. He didn't say much in class. Sometimes he would just come up to look at your painting, hold his hand up to it, and grunt twice. The photography teacher was very old. He spoke with a German accent and looked exactly like Stieglitz. I never learned anything in photography class. I couldn't take a good picture because I could never figure out how to use a light meter. But the darkroom was a great place to make out with Carol Muckenfuss.

The art academy was a very traditional museum school connected to the

Cincinnati Art Museum. My art history teacher was the director of the museum. He was tall and distinguished looking. He wore shoes with metal clips on the heels, and when he walked through the museum you could hear him coming. Every teacher in my school was a stereotype right out of art history. Even my graphic design teacher, Noel Martin, had leather patches on the elbows of his tweed jacket, wore khaki pants, and was always smoking a pipe. He was my best teacher. He liked jazz and was a famous designer who drove a now-classic 1953 Studebaker. He said that as a designer he owed it to manufacturers who put well-designed things into the marketplace to buy their products. I never forgot that. I have used that principle all my life. I constantly redesign in my head everything that I see.

Alon Schoener was my other great teacher. He taught contemporary art history and was the curator of the Contemporary Art Center. I worked for him as a preparator after my first year in art school. The art center was in the museum in those days. Later, after I moved to California, it moved into its own space downtown.

I tried to get Schoener to go to Babe Baker's jazz club with me, but he (like most white people in Cincinnati then) was afraid to go to an all-black club. Babe Baker's was the hippest place in Cincinnati in the 1950s. One of the members of the art center wanted me to get a book of matches from the club so he could impress his friends by having the matches on his coffee table at home. The house band at Babe Baker's was called the Modern Jazz Disciples, and whenever anybody who was anybody in jazz was passing through town they would sit in. I saw many great players there, including Lester Young with his porkpie hat, drinking scotch and milk because he had an ulcer.

1958

I went to New York for the first time in 1958. I was an art student. It was
in the summer. I drove my father to meet a childhood friend from Italy, a
friend he played with when he was thirteen years old in Livorno. My father
grew up near there and went to school in Pisa. His friend, Dr. Gambazzi,
also became a doctor. When Dr. Gambazzi, who had a daughter the same
age as me, wrote that he wanted to make a visit to America and look my
father up, my father was very excited. He told me that Dr. Gambazzi was
coming with his daughter, whose name was Goya, on the *Leonardo da Vinci*
cruise ship from Italy, and he wanted to take me with him to meet them in
New York. We drove to New York in our new Ford convertible. I was twenty-
one at the time.

It took two days to drive to New York, and it was a chance to be with my
father, which was a nice experience for me. When we got there, the first
thing we did was to go to Mama Leone's, the most famous Italian restaurant
in New York. We had spinach ravioli, my favorite food. I was interested in
jazz so the next thing we did was go to a jazz club. I took my father to
Birdland.

After we met Dr. Gambazzi and Goya, my father and I took them to the
Embers, a jazz supper club. George Shearing was playing. Billie May was
in the audience. He was sitting at the table next to us, and George
Shearing said, "We're honored to have Billie May in the audience tonight."
Then Billie May stood up, right at the next table. One of the first jazz
records I ever had was by Billie May. He had a big band and played post-
swing era big band jazz. He made the saxophones slide into the notes the

JAZZ RECORDS

way a trombone might do it. He had a big hit called "My Lean Baby."

Goya didn't speak English and I didn't speak Italian. The way we communicated was by dancing. When we got back to Cincinnati, I brought her down to our basement and danced with her. I had fixed up the basement of my parents' house and made it into the equivalent of what I have in my studio now, a party room. I had a big hi-fi speaker. It was before stereo. I brought Goya Gambazzi down there and put on the music, and we danced. I could never kiss her because she said, "It is not in Italy like it is in America." She said, "I am not like Gina Lollobrigida in the movies." I never got to first base with her, but we did a lot of dancing.

My parties weren't dancing parties because you don't dance to modern jazz, you listen to it. People came because I had jazz records. I had discovered that the secret to a good party is having good music. I played it loud, but you could talk over it. It was so loud that you had to talk *over* it, but it wasn't so loud that it was deafening; it just kept things moving. People brought their own beer just like they do in my studio today. One time I

invited some friends from art school over for a King Kong party, because the movie *King Kong* was on TV. We drank beer and watched TV. Later, in 1973, in San Francisco, when I started a weekly salon on Wednesdays and showed artists' videotapes, I got a grant to have free beer, and it was beer and TV all over again. A lot of the things I did in art school were things that I later ended up making the subject of my art.

San Francisco, 1959

I graduated from art school in 1959, and the next day I got on a train with my portfolio and went to California. I traveled by coach for three days, changing in Chicago. At that point, I had never flown in an airplane. After I arrived in San Francisco, I got a furnished room at 2246 California Street near Fillmore for forty dollars a month. Every Monday, the landlord would give me a clean sheet and a clean pillowcase. I would give him the bottom sheet and put the top sheet on the bottom and the new sheet on top.

The room had a sink, and down the hall were a kitchen and a bathroom that everybody in the house used. Some interesting people lived there. There was a guy from Dartmouth College with an Austin Healey sports car; we drove all night to Monterey, California, one time. And a crazy guy from Hungary who got drunk every night and cussed out the Russians; he had to be taken away. The rooming house was near Fillmore Street, the center of the Fillmore District, where the tail end of the jazz and blues era in San Francisco was playing out. There were a lot of clubs, mostly for blues. Jack's on Sutter was an important one; I saw B. B. King there and Big Mama Thornton who recorded "Hound Dog" before Elvis Presley did.

I preferred jazz to blues and I used to take the cable car to North Beach

and stand outside the Jazz Workshop to listen. Most of the time I couldn't afford to go in. Even though my rent was only forty dollars a month, I made only forty dollars a week. I worked as an assistant to a designer, a commercial designer who designed rugs and wallpaper. I listened from the sidewalk to a lot of important jazz people, but I also went inside and heard Ornette Coleman, Cannonball Adderly, Roland Kirk, and others. I would sit at the bar and have one beer for eighty-five cents and stay for a whole set. For eighty-five cents I heard John Coltrane play.

Later I had a motorcycle and a conga drum. I used to play my drum on a street corner in North Beach. In those days that was a way to hang out, be part of the street scene. I went to the Jazz Cellar, the Co-Existence Bagel Shop, and the Coffee Gallery where Pony Poindexter regularly played alto saxophone. One night I heard a lecture at the Coffee Gallery by Benny Bufano, who had designed the Indian-head nickel and used his own profile on it. I was very naive about being an artist. I didn't know where any galleries were, and I didn't think to look them up in the Yellow Pages. There was only one contemporary art gallery in 1959 in San Francisco. It was the Dilexi Gallery, upstairs from the Jazz Workshop. I used to stand outside the Jazz Workshop, and I didn't even know the best gallery in San Francisco was upstairs.

About three years later, Basin Street West came in down the street. I saw Lenny Bruce there. He was from another planet. I heard things that I had never before heard discussed in public. He talked about sex, drugs, race, and homosexuality, and he ridiculed religion. Everything Lenny Bruce said was shocking, but funny too. Once there was a black guy sitting up close to the stage, smoking a cigarette. Bruce looked down from the stage and said,

"Can I have a light?" The black man (who was planted there by Bruce) handed him his lit cigarette, and Bruce said, "Look, he nigger-lipped it." And that was the beginning of a monologue about racism. He was so fast and so smart. In one of his routines, he described the time of Christ, with Christ standing in the back of the church with some others. An official asks, "Which one is Jesus?" And Bruce answers, "He's the one that's glowing."

1960

In 1960 I got drafted into the army. A friend of mine had been drafted six months before me and had been sent to Korea. Although the Korean War was over and the Vietnam War hadn't started yet, most draftees were being sent to Korea.

When I got my draft notice, I went down to the enlistment office and asked if there was any way I could be stationed in Europe. The sergeant in the office told me how to do it. "Take your draft notice and write on it: Moved, Address Unknown," he said, "and it will go back to your draft office in Cincinnati. Then you can come back here and enlist." I did that and the next day went back to the office in San Francisco and signed up. The only problem was that when you signed up it was for three years, instead of only two if you were drafted. But by enlisting you could choose where you wanted to be stationed. You had three choices: Asia (Korea), Europe (Germany), or the U.S. I thought if I went to Korea, I would be completely isolated from the rest of world, and if I stayed in the U.S., I might be stationed in Oklahoma for two years. But if I went to Europe, I would be in Europe. I chose Europe even though it would be for an extra year. I figured it was worth it.

I was stationed in Ulm, Germany, where Einstein was born. It was also

the city where Max Bill founded his own postwar Bauhaus, a famous design school. Ulm is a beautiful city on the Danube River.

I was a private in the infantry. In my spare time I painted a mural in the meeting room of my company, Company A. It was a battle scene, a bunch of soldiers charging up a hill with tanks. It was done in a more-or-less realistic way, but loose, kind of an Impressionist style. Somebody took a photograph of me in front of it for the *Stars and Stripes* newspaper and wrote a little piece about me. It read: "Beatnik Artist Finds Army Life Not too Difficult." After that, I applied for a transfer to the *Stars and Stripes*, which was in Stuttgart.

With my application, I sent my resume. I had graduated from art school and worked for a year in San Francisco. Of course, I padded my resume to make it look like I'd done more than I had. The editor of the *Stars and Stripes* wrote me a letter that said: "We'd like to have you on our staff as an artist and illustrator. Apply through normal channels and include this letter."

So I did that. You have to go through the chain of command, and I had to go all the way up, from the lieutenant to the captain to the major, and I finally got to the colonel. When the colonel in charge of my battalion got a copy of the letter from the editor of the *Stars and Stripes*, along with my resume, he called me into his office and said, "I had no idea we had such a great artist right here in the battalion." From that day forward, he called me Frank Lloyd Wright. He said, "If we put through this transfer and it gets approved, we'll lose you. But if you agree to forget about applying for a transfer, I'll give you your own office and make you Battalion Artist. You can be in charge of the beautification of the battalion."

I decided to stay. It turned out to be a good gig. I was only a private, but I had a U.S. government charge account at the art supply store downtown. I started out painting realistic murals and gradually got to the ones I wanted to paint. I was accepted as a legitimate artist. I painted murals in the library, the post office, the officer's club, the officer's mess hall, and the enlisted men's mess hall.

I was reading Henry Miller's *Tropic of Cancer* at the time; it was available in Europe but had been banned in the U.S. ever since 1934 when it was published. I copied out this quote and hung it up in my office: "For the man in the paddock, whose duty it is to sweep up the manure, the supreme terror is the possibility of a world without horses. . . . A man can get to love shit if his livelihood depends on it." That quote was appropriate for someone like me who was in the army and actually liked army life.

I also read *Tropic of Capricorn.* On the very first page Miller wrote: "I had no more need of God than He had of me, and if there were one, I often said to myself, I would meet Him calmly and spit in His face." This was even more shocking to me than anything I heard Lenny Bruce say. I had rejected the Catholic religion, become a bohemian artist, and discovered literature all in my early twenties.

I was in charge of a squad made up of carpenters and house painters who painted the outside of buildings. Company A was one color, Company B another color. Before that, all the buildings had been painted the same. The colonel in charge of the battalion got special recognition for the beautification. I didn't need passes. I had a Volkswagen. On weekends, I took off and went to different parts of Germany. Munich was happening then. There was a jazz scene there in '61 and '62.

CONCEPTUAL PAINTING

Marilyn Swensen, my girlfriend from San Francisco, came over and we got married. We moved into an apartment. Our first son, Marino, was born before we left Germany. I didn't make very much money, but it was more money than most German workers made, and German soldiers got practically no pay. Our apartment was thirty dollars a month. A beer was fifteen cents. What I made as a private in the army was ninety-eight dollars a month.

One mural I painted turned out to be, maybe, my first Conceptual piece. It was on a wall in a meeting room. There was some dampness in the wall and, before I began, the paint was already starting to peel. I got a putty knife and scraped off the old paint, like you normally do when you are going

to paint something. It came off easily where it was loose, but otherwise it stayed. The scraping created shapes that looked like continents on a map. Very carefully, with black paint and a small brush, I painted a one-inch black line bordering the shapes. By doing that, I framed the bare plaster wall where the paint had peeled off. That became the mural. It wasn't pictorial. It was about the process. That made it more conceptual than pictorial.

I painted my best mural in the officer's mess. It was abstract, like a Mondrian, only with curved shapes as well as horizontals, verticals, and primary colors. There was a lot of white, red, yellow, and blue with black lines. It filled the whole wall, very bold. The major came in and looked at it and said, "I don't like that blue. That is Milk of Magnesia blue and it reminds me of when I was a kid and I had to take Milk of Magnesia." I said, "That's the only blue that works." And he said, "Well, okay."

Battalion Artist was a completely unauthorized job; the army had no such category. They had sign painters, but they didn't have artists. I was in an unauthorized, invented job, so I couldn't be advanced in rank. I remained a private the whole time I was in the army. But I had the only office in the battalion with a lock on the door. The mess sergeants and the cooks would come up to my office and bring me beer so that they could drink a beer on duty. They knew I could lock the door. They would bring me food too. My office was next door to the office of the captain who was in charge of all the dining halls. We ended up becoming friends.

I had an assistant who was a painter. His name was Roy Mallet. He was sent on special duty to Washington, D.C,. from Germany to play the chess champions of the air force, the marines, the navy and the army. They were all generals and admirals and people like that. He was a private like me. He

won. He became the chess champion of all the armed forces.

You couldn't join the army after age thirty-five, and Roy Mallet was thirty-five when he joined. Before that, he had been working for fifteen years at odd jobs. He spoke five languages fluently and was one of the best chess players in the world. He had played in tournaments—he even played in Russia once. But playing chess and speaking foreign languages were not practical skills back then, and he didn't know what to do with his life. So he joined the army. He was from New York and liked to paint. "Roy Mallet the Artist." That's what I called him.

Painting was a hobby to him. He didn't know a lot about art. He used to play chess with Marcel Duchamp in Washington Square, but he didn't have any interesting stories to tell about Duchamp. They just played chess. I knew about Duchamp from my art history class in art school, but at that point he was only a historic figure to me. Now it's different. Picasso said, "Cezanne is the father of us all." But he was a painter. As a Conceptual artist, I would say that Duchamp is the father of us all.

In 1912, Duchamp painted one of the most famous paintings of the twentieth century, *Nude Descending a Staircase*, which a newspaper at the time called "an explosion in a shingle factory." It created a scandal in the 1913 Armory Show in New York City, the first international modern art show in America. Duchamp never repeated himself in his art. A few years later he invented the concept of the found object or, as he called it, "ready-made," a common object presented in an art gallery as fine art. The most shocking of his readymades was a urinal called *Fountain* that he showed in an exhibition of the Society of Independent Artists in 1917.

In the 1920s, Duchamp announced that he was giving up art in favor of

playing chess. I think he was renouncing painting, not all art. I read some-
where a description of his studio in the '50s, and it made a powerful
impression on me. It was a small room with a table and a chair and a crate
that was used as a second chair. On the table was a chessboard set up to
play. In the corner was a cot. There was a path in the dust on the floor that
led from the door to the table to the bathroom. Two walls had nails in them,
one nail with a piece of string hanging from it. Pictures had hung from the
nails, and when they were removed I think that the nails became ready-
made objects of sculpture.

In a way, this is a Duchamp work that I have created in my mind. I don't
think he intended the nails to be artworks. But in 1989 I hammered a nail
with a piece of string hanging from it into the back of a shadow box that made
a frame around it, and in that way I made a small work about Duchamp.

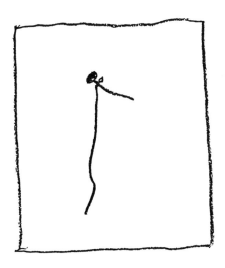

FROM PAINTING TO SCULPTURE

After Duchamp died, it was discovered that he really had two studios, one to see visitors and play chess in, and the other one to complete his secret twenty-year (1946-1966) work of installation art, *Étant Donnés*, which is now in the Philadelphia Museum of Art.

Six months before my time in the army was up I was transferred back to the States. I wanted to stay in Germany for the whole time, but the army has the idea that if you're overseas for more than two years, it's a hardship. I told my commanding officer, "Believe me, it's not a hardship. I don't want to go back to America to spend my last six months. Let me stay here another six months." They even pay you less in the U.S. because being overseas is considered a hardship. I was sent back anyway and was stationed in Columbus, Georgia, one of the worst places in the world. When I got there, I figured out a way to get myself assigned to a sign painting shop, and I was a sign painter for six months.

This was in '63 when Georgia was still the deep south, before civil rights. Because I was married, I was able to live off-post in an apartment. We had a neighbor, a nice old lady, the sweetest old lady, with lace doilies and things like that. Kennedy was president, and Jackie Kennedy was pregnant. It was her third child—she later lost it two days after it was born. Our neighbor, the sweet old lady, said, "I hope that Jackie Kennedy has a nigger baby." That's when I really understood what Columbus, Georgia, was about.

My wife and I would go into a bar and we looked different. I guess I was wearing my tailor-made Italian-silk suit. I heard somebody at the bar say the word *slicker*. "City slickers."

1963

When I got out of the army in Georgia in 1963, my brother Paul gave me his 1955 Oldsmobile. He was always getting good deals on cars. He drove it down and gave it to me, and we drove back to Cincinnati together. Then I drove out to San Francisco with Marilyn and our one-year-old, Marino. We got an apartment at Jackson and Hyde Streets for eighty-five dollars a month. It was a two-bedroom railroad-style apartment, over the Broadway tunnel, up on Russian Hill. I had a letter of recommendation on official consulate stationary from my father, who was the Italian Consulate for Cincinnati, Ohio. He wrote: "Any consideration given to my son in finding employment or housing would be appreciated by me." Luckily, the landlord and landlady were Italian. I showed them the letter, and we moved right in. They were first cousins of Tony Bennett. He used to come and visit them; I would see him in the hallway.

Marilyn got a job in an employment office. I was home taking care of Marino when President Kennedy was assassinated. I remember watching it on TV in the front room of our apartment. We were on the cable car line, and I can still hear the bell from the cable car whenever I think of that.

Later, when I got a job downtown, I used to gulp my coffee in the morning and run up the hill after the cable car like Dagwood Bumstead and jump on the back. I rode it to the end of the line at Market Street by Woolworth's. Woolworth's had a cafeteria where Benny Bufano had painted a mural in exchange for free meals for the rest of his life. San Francisco seemed quiet at the time. The Vietnam War hadn't happened yet. It was before the Beatles hit the U.S., but after the Beat scene in North Beach.

I was too young to have been a beatnik and too old to be a hippie.

We were living in an Italian apartment house, on the outskirts of Chinatown. My son Tony was born in 1964. He went to the neighborhood school, which was all Chinese. Once he told me that his teacher had said, "When you are home you should only speak English."

Tony used to say, whenever he had a stomachache, "I think I have digestion." One time in 1970, when he was six years old, he lay down on the sidewalk with his feet touching a parking meter. He was the same length as the meter was tall. He said, "Body Sculpture." Another time, some people came to my studio to look at my work and consider me for a grant. I asked Tony if he would do his trick with the cap gun caps under his foot. He jumped backward, sliding one foot on the sidewalk, and the roll of caps went off, making sparks and a firecracker sound. I told the art committee that this was an example of my work. They were mystified and not ready for performance art performed by the son of the artist. Tony is now in his late thirties and has become a world traveler.

In 1967, my son Miles was born. We named him after Miles Davis, who just before that had come out with an album called "Miles Smiles." He was a very cute baby; our friends would say, "Look at the Little Binkie."

I used to tell my kids that whatever they did, they should do it as though they were artists. Miles studied art at U.C. Davis. He lives in the Bay Area. He went the same route as my brother Paul, fixing cars. Then he went from fixing cars to fixing houses. That's what a lot of graduate art students do until they find a place in the art world. My oldest son, Marino, shortened his name to Reno, which is a great name. When he was born, I thought the name Marino Marioni rolled trippingly from the tongue, but it's also a

mouthful for most people. I named him after Marino Marini, the Italian sculptor who made those horse-and-rider works in the '40s and '50s. Also, my father's first name was Sereno, and I thought it would please him that my son had such an Italian name. Reno is a media and digital artist. He works creatively in that field with his wife, Jackie. They approach programming with the same intensity and imagination that artists use.

My first job when I got back to San Francisco from the army was in a plaster shop as a finisher, painting faux finishes on plaster objects, lamp bases mostly, and classical sculpture. I am color-blind, and in this job that was a handicap. I always had to ask other workers, Does this color look right? Does this look like the original? My boss didn't know I was color-blind.

Some of the work involved painting with a brush and rubbing the finishes, but mostly I was spray-painting lacquer in a spray booth with an exhaust fan on top. I had a mask, but if you're doing that four hours a day, or sometimes all day long, you get a lot of fumes, even if there is an exhaust fan and you use a mask. Over hours and hours the lacquer smell permeates you. I used to have mild hallucinations. I would get some fantasy ideas. I got laid off after a couple of years. I was lucky that I didn't work there longer. It could have done permanent brain damage, I think, I'm not sure, where was I?

At the same time, on weekends, I worked in a nightclub in the Outer Mission called Relax with Yvonne. I drew a nude model. It was an artist-and-model act. At the time, there were topless dancers but total nudity was outlawed, unless it was called "art" and the model didn't move. My model

would get up on a stand like in an art school, and then let her robe fall away. After that, she would hold the pose. I made charcoal sketches on a big pad of paper that was on an easel, five-minute sketches, and then she would take another pose.

People would sit at the bar or at tables and watch this. It wasn't very entertaining. They would watch me because I was the one doing something. But it was a chance for them to see a naked woman. The job didn't last long, only two months. It sowed the seeds for my work as a performance artist that started a few years later.

In the late '60s, I went to the Monterey Jazz festival with an old Cincinnati friend, Alvie Leurson. It was on a Saturday night in September. The concerts had ended, it was about midnight, and we were driving in Alvie's green Plymouth looking for someplace open to get something to eat. I saw a red Ferrari going the other way. I knew it was Miles Davis. He always had Ferraris, and I had read in *Downbeat* magazine that he was going to ship his car to the festival. I said, "Alvie, follow that car." We made a quick U-turn. The Ferrari pulled up to an all-night diner, and we followed Miles and another guy in. They sat at the counter, and I sat next to Miles with Alvie on my right.

I said, "Excuse me, do you have a light?" and Miles handed me a book of matches. His friend said, "What do you want to give that honkie a light for?" and Miles said, "Shut up." I lit my Lucky Strike, handed the book back, and said, "Thanks, man." I knew I couldn't say, "I'm a big fan of yours." He would have come back with the line he was famous for, "So what?" Miles even wrote a song called "So What." The only thing I could do to have any contact with him was to act polite and pretend I didn't know who he was. In

A LIGHT

the late '80s, when Miles was in his final years and playing his trumpet as
though it were a rhythm instrument, I went with my friend Masashi
Matsumoto to see him play in Berkeley. At the end of a great performance
everyone was screaming and applauding, and Miles went to the microphone
and said in his raspy voice, "That was nothin'. I do that every night." He let
the audience see him as a person, not only as a musician. This was a long
way from the '50s when I saw him play part of a set with his back to the
audience.

I heard a story about an interviewer who asked Miles what he thought
of Wynton Marsalis. Marsalis was playing like early Miles at that time,
with the same muted trumpet sound. Miles said to the interviewer, "I hate
that motherfucker." This was the time of appropriation in all the arts, and
Miles had said that the old way of playing jazz, where everyone takes

turns playing solos, was "some boring shit."

All during the '60s there was an art scene in San Francisco. Wanda Hansen opened a contemporary art gallery and I showed my work there. The gallery showed mostly graduates of the San Francisco Art Institute, and I got to know the Bay Area art scene through them. I learned about the figurative art tradition in San Francisco. In the '50s, Richard Diebenkorn, David Park, and Elmer Bischoff were the main figurative painters. They were Abstract Expressionists who broke away from that movement and did paintings with figures, very expressionistic figures, not realistic, and with loose, heavy paintbrush strokes. This was a separation from the avant-garde of New York, from de Kooning and Pollock, the big Abstract Expressionists in the '40s and '50s.

Besides New York, San Francisco was the only other art center in the U.S. in the '50s. L.A. hadn't produced its own art movement yet; that came later. In San Francisco in the '60s, there was a new generation that broke away from Diebenkorn and Park. Bruce Conner and two students at the Art Institute, William T. Wiley and Robert Hudson, carried the figurative idea further, by adding an element of Surrealism. They made sculpture. In the '50s, the figurative artists were painters.

In 1965, Peter Selz, a curator from the Museum of Modern Art in New York, was hired as the first director of the University Art Museum in Berkeley. In New York, Selz had organized the Jean Tinguely exhibit. Tinguely made a giant kinetic sculpture called *Homage to New York* in the museum courtyard in 1960, and as part of the event it destroyed itself with explosives. There were motorized parts that fell apart or were blown up. It was a famous show; then, a few years later, Selz was in Berkeley. Rather

FIGURATIVE

than just bring New York art here and show it, like most curators who move
to San Francisco, he looked around and found out what important art was
being done in the Bay Area at the time. He coined the term "Funk Art" and
organized a show at the Berkeley museum in 1967. *Funk* was a jazz term
that referred to a bluesy soulful style, sexual and humorous. The show
included Wiley and Hudson and other artists like Joan Brown and Robert
Arneson. It brought to the attention of the art world a San Francisco style
that was organic, a loose kind of art, the opposite of the tight and clean Pop
Art and Minimal Art of New York.

Because of that exhibition, San Francisco was back on the art map

again, like it was in the '50s. Funk Art became the art of the '60s in San Francisco, and the San Francisco Art Institute was the center of Funk Art. This hundred year-old art school was the establishment. Whenever the Whitney Museum would organize their annual countrywide exhibition, they would send a curator out here to look around, to find out what was going on. The curator would visit artists who were recommended by the Art Institute, and some of them were invited to be in the Whitney Annual. That affirmed the notion that Funk Art was the art of San Francisco.

In 1967 I was out of synch with San Francisco art, making Minimal sculpture influenced by New York and Los Angeles. In L.A. Larry Bell and John McCracken were making Minimal Art with color (unlike New York). My sculptures were orange and blue curved forms with lacquered fetish-finishes, like custom cars. But I was hearing about new experimental art being done in New York, and I made a series of word pieces on shiny white paper with a peel-off back, like bumper stickers. I rubbed down letters from sheets of type you could buy in art supply stores. I called these works "refrigerator graphics."

I gave my brother Paul one of them that read: "Art is a bunch of shit but I love it." This one came from the Henry Miller quote I had put up in my army office. Paul stuck it on the door of the refrigerator in his Mill Valley house. He had a silkscreen print in his living room that was done in the early '60s by Sister Mary Corita. It was just handlettered words that said: "Makes meatballs sing." This nun, Mary Corita, was a follower of Ben Shahn, the painter/illustrator of the '40s and '50s. I liked her work from when I was in art school. She was never considered a Language Conceptual Artist because her words were hand-drawn, with some expression, and not

REFRIGERATOR GRAPHICS

printed in plain type. But her work was a kind of Language Art.

I gave one of my refrigerator graphics that read "Kelvinateher" to George Neubert, a curator at the Oakland Museum. He told me he put it on his refrigerator, and one of his friends told him that was not how you spelled Kelvinator. Of course, my word came from an old joke: Did you hear about the girl in the appliance store? No. Kelvin ate her. The San Francisco Museum of Art had a rental gallery in it in those days, and I was invited to be in one of the early shows. I submitted a refrigerator graphic that was on a larger-than-usual sheet of white stick-on paper. It was put on the wall

with pushpins between two framed works. It read: "Rented by Gerald Nordland." Nordland was the director of the museum at the time, and I thought people would assume that he had rented my work. This was a joke that I didn't expect would end up in anybody's home, but most of my refrigerator graphics were put on refrigerators.

When a graphic was on a refrigerator, the refrigerator became a piece of sculpture to me. Sculpture was where it was at, an intellectual pursuit, no longer architectural ornamentation. In the '60s, Minimal Sculpture, and then Anti-form Sculpture, had taken the stage away from painting. Even Andy Warhol declared painting dead. Painting had no more power. Painters even tried to imitate sculpture by claiming that a painting was an object and painting was only about paint. I think it was the painter Ad Reinhardt who said that a sculpture is something you bump into when you are backing up to look at a painting. Leonardo, who was a rival of Michelangelo, wrote that painters are gentlemen in fine clothes working indoors with musicians playing, and sculptors (like Michelangelo) are covered in marble dust working out in the cold.

By the end of the '60s, Conceptual Art had been born. It was an international art movement that happened simultaneously throughout the world, but in different ways depending on the country. In Germany it was scientific, like Joseph Beuys's sculpture experiments generating heat and electricity. In Italy it was theatrical, like Luigi Ontani in costume reliving the Italian Renaissance. In France, it was theoretical, like Daniel Buren's painted stripes placed in the real world to make a frame for it.

In England Conceptual Art was about the land, like Richard Long taking walks in the countryside, arranging stones in the landscape, and photo-

graphing them to record the work's existence. In Eastern Europe it was about political repression, like Gabor Attalai's piece titled *In Isolation (when a Man Cannot Give or Get Information)* in which his eyes, mouth, ears, nose, and fingertips were covered.

In New York Conceptual Art was about language and systems, like Robert Barry's wall label describing radio waves in the gallery, and Sol LeWitt's wall drawings executed by others according to a written plan. In Japan it was spiritual, like Yoko Ono's written direction to pay attention to what's around you. In Los Angeles, artists like Robert Irwin created temples of light. In San Francisco, there was an emphasis on the body.

By 1968 I had stopped making objects and was working with sound and with ideas that came out of the body, so I no longer felt out of sync with San Francisco. Body Art was an extension of San Francisco's figurative tradition, more experiential and more real than the work of the Bay Area Figurative painters and the Funk sculptors. It developed in the time of free speech, free love, the hippie era of drugs and rock and roll. Body Art existed in Europe and New York as well, but here it had its own slant, with an element of everyday life added to the performance aspect. I wanted to make art as close to real life as I could without it being real life. Art and life should not be confused. God makes life. People make art.

1968

In 1968, I went to work at the Richmond Art Center, and my life changed. That's when I moved into the real art world. I applied for the job of curator in that small city north of Berkeley, and I passed the test. The test was in three parts: a written test, an interview, and an identification of

tools. The curator had to do everything at Richmond, since they didn't have much of a staff. There was a guy who was called a preparator, but he was more like a union janitor. The curator did the heavy moving, and he would hang the shows, so the job couldn't go to some private-school girl who would never hammer a nail. That was why the identification of tools was part of the test.

I had to identify pliers, a screwdriver, a wrench, and a hammer, and then explain what they were used for. A woman applicant had already passed the interview and written test. She was a friend of a woman on the interview panel who gave all the other applicants really low grades and gave her friend she gave one hundred on the interview part of the test. So her friend won, because the scores were averaged. The administration decided to do the whole process over and add the tools part of the test. They really didn't want to hire this woman because she would never hammer a nail. Of course, that wouldn't work today because people would see through it. But it was to my benefit. I wasn't going to complain about the hiring practices unless they rejected me because I was Italian-American.

I had to have a physical because it was a city job. I went to the city doctor and took the physical, which included an eye test. I flunked the color-blindness test. The doctor knew only that I was applying for a job with the City of Richmond, and he said, "Oh well, I guess that doesn't matter. What are you, a gardener for the summer for the parks department?" I said, "Yes." He said, "O.K., it doesn't matter." If I had said I was going to be Curator of Art, he would have said I couldn't have the job.

I found out I was color-blind when I was in high school. I took one of those tests with the little dots, the colored dots with the numbers hidden inside.

TOOLS

When you get a driver's license you have to take one of those tests. You look through a viewer and there's a bunch of little colored dots and you see a number seven or a number eight in the dots. If you're red-green colorblind like I am, you miss a lot of the numbers. They look like a sea of dots that are more or less the same color. Red dots and green dots all look the same.

The way I always pass the color-blind part of a driving test is by standing close to the person in front of me and listening to him say the numbers: "seven, six, nine, four." Then when I get up there, I say "seven," and as the

numbers are changed, "six, nine, four." To me, purple looks blue because I don't see the red in it. Sometimes I look at a bunch of roses with a lot of greenery and it all blends together. I can't see the roses; it just looks like a bunch of green, actually a bunch of gray. Sometimes if I see a very bright red, it does look red, but it probably looks less red to me than it does to others.

Some people, not very many, are totally color-blind and everything is black, white, and gray. Those people were used in the army in World War II because they were really good at spotting camouflage. From the air, camouflage is brown and green, to suggest foliage, but if you don't see the color it doesn't look natural. Of course, now the same thing can be done by using a video camera with a black-and-white monitor. If you had something that was 50 percent value red and 50 percent value green and you saw it on a

PICASSO'S NOSE

black-and-white monitor, it would look solid gray. But if it was slightly off, a color-blind person would see it.

Funny thing is, I think a lot of artists are color-blind, more than people would realize. If you're color-blind and you're doing a painting that has only one color in it, that's not an issue. There are also a lot of artists who are dyslexic; that is why they become artists and not writers. Once in a while I write a *b* as a *d* or a *d* as a *g*. Sometimes I even write a character upside down. This usually happens when I'm writing a letter. When I go back and reread the letter, I catch it. But I don't catch it at the time I'm doing it. Picasso wasn't good at math because every time he saw a 7, he thought it was an upside-down nose.

1969

At Richmond I did ceramic shows, painting shows, and photography shows, all kinds of shows. There were also some Conceptual Art shows. Tom Wolfe, in *The Painted Word*, called the Richmond Art Center, under my direction, "that great outpost of invisible and conceptual art." One early show (1969) was called "Invisible Painting and Sculpture." Wally Hedrick showed an all-black painting from his "Vietnam Series" to protest the Vietnam War. Harry Lum showed an all-white painting with the comment, "No work of art can be presented to the unwilling, unfeeling viewer." Bruce Conner sent in an empty envelope. William Wiley had these words lettered on the entrance to the gallery: "Please do not touch yourself."

This was the first time I put myself in a show that I organized. Since the show was about invisibility, I could do it without anyone knowing. I did not have an artwork in the gallery or include my name on the list of artists, but

in the catalogue there are two blank pages where "Marioni" would be alpha-
betically. Ever since then, much of my work has had an element of invisibil-
ity. I like the idea that the work is invisible until a person looks for it and,
by following clues, discovers it was there all the time. Sometimes I think
that my ideas are clear as glass, so clear that they are invisible.

My alter ego, Allan Fish, appeared after the "Invisible Painting and
Sculpture" show in an exhibition I organized the same year at Richmond
called "The Return of Abstract Expressionism." I had intended this to be a
sculpture show, and I needed a particular work for it. The way it was going,
there were too many things on the wall. So I created an artist in order to
have another floor work. The artist, Allan Fish, sent instructions to me (the

BIRDS IN FLIGHT

curator) so I could execute his work. These were the instructions: "Enclosed is a packet of multicolored construction paper. To install the sculpture, sit in a chair about ten feet from a wall. Take one sheet at a time and crumple each one, as if you were in a hurry and throwing it into a wastepaper basket. Throw each piece at the wall, trying to keep them generally in a confined area. The result should be multicolored birds at the moment of flight after being frightened by the stamping of feet."

The show was about extending the painting of the '50s, but it was not about action painting. It was about actions and materials. At the end of the '60s, artists were reacting against Minimal Art and were starting to make art that was about natural forces and raw materials, and were using chance and gravity. Terry Fox had a piece of plastic blowing outside in the wind. Mel Henderson stacked a cord of cut firewood in the Sculpture Court. Dennis Oppenheim showed a photo blowup of an earthwork and John Woodall made a rubber mold of the floor of his studio and laid it out on the gallery floor. *San Francisco Chronicle* critic Thomas Albright wrote that "Marcel Duchamp stated that art is anything the artist says it is." This, Albright said, allowed him to propose "that nothing will be reviewed by me unless I say it's art." Future press releases about "unstructured natural and man-made phenomena," he said, should be sent to the walk-through editor or the travel editor.

My last show at the Richmond Art Center was in early 1971, before political correctness. It was called "California Girls" and was one of the first feminist art shows in the country. Joe Salvato, the boss of Richmond's Parks and Recreation Department (which controlled the art center), was looking to fire me, and this show presented him a perfect excuse. I had invited about

thirty women artists to exhibit. Judy Chicago was one of them. She was teaching a feminist art course at Fresno State University at the time, and she invited one of her students to present a performance at the opening of the exhibition in her place. Salvato had heard something bad was going to happen that night, so he arrived early and stayed for the whole thing. Near the end, Judy Chicago's student rolled a long sheet of white butcher paper up the entrance hall. Then she began to crawl on her hands and knees along the paper. Strapped to her belly was a milking machine that spilled cow's blood on the paper as she crawled. I was fired the next day. They had fired the director, Hayward King, six months earlier because he wouldn't fire me, so now they had no one. The art center's ceramic teacher, who had snitched to Salvato in advance of the performance, was appointed director the day after I left. Ten years later, he got poetic justice. He was fired two months short of his retirement and lost his pension.

Hayward King got another job right away at the Palo Alto Cultural Center. He died in the late '80s. He was one of the original members of the Six Gallery, an artists' co-op gallery in the '50s where Allen Ginsberg first read his poem *Howl*. Hayward was African-American and was from Los Angeles. His father was an airplane mechanic for Howard Hughes, and when Hayward was eight, Hughes gave him a ride, with Hughes flying the plane and Hayward in the copilot's seat.

Every year, Hayward would spend his vacation in Paris, visiting a friend who was a curator at the Louvre. His friend told him that the *Mona Lisa* painting on display in the Louvre is not the real one. There had been so many attempts to steal or deface it that they put up a copy in its place.

One summer when my wife, Kathan, and I were in Paris we stood in line

to see the *Mona Lisa*. When we came to the room where it was, there were five hundred people in the room, most of them shooting flash pictures of the small painting behind tinted, bulletproof glass. If this were not a copy, I don't think the museum would allow ten thousand flash bulbs a day, day in

MONA LISA

and day out. At this point, the *Mona Lisa* is a shrine, and that is what is important, not the actual painting. Duchamp burst the bubble by drawing a mustache on a reproduction of it and titled it *L.H.O.O.Q.* Conceptual artists often make work that is short-lived and can be remade later. It matters that

the idea is original, but it doesn't always matter whether the object is the original one the artist made.

While I was a curator at Richmond, I used to make trips to L.A. to see what was going on and visit my friends Larry Bell, Chris Burden, Barbara Smith, and others. Once Larry Bell invited me to come with him to Irving Blum's house to have dinner with Jasper Johns. In the '50s, Johns made paintings of things like targets and numbers that were already two-dimensional, and he changed painting forever. At dinner I told my story about the *Mona Lisa* being a fake. Afterward, I asked Johns if he had ever seen any fakes of his paintings. He said, "Impossible."

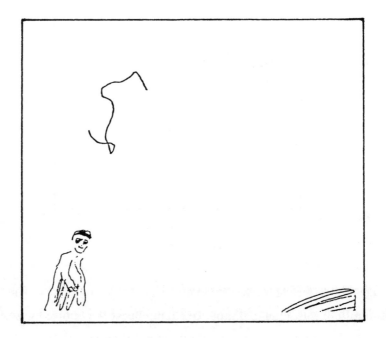

ONE SECOND SCULPTURE

My three years at the Richmond Art Center made me well known in the Bay Area as a curator and overshadowed my image as an artist. It was at about that time that I began to make actions and performances. In 1969, in one of my first art actions, I made a work called *One Second Sculpture*. This was a way of combining Performance Art, Sound Art, and drawing in a single work, and I recorded and photographed it. My instrument was a rolled-up metal tape measure. I threw it into the air, and in one second it opened like a spring, making a loud sound. It left my hand as a circle, made a drawing in space, and fell to the ground as a straight line.

Museum of Conceptual Art, 1970

In 1970, working under the pseudonym Allan Fish, I made an exhibition in the Oakland Museum called *The Act of Drinking Beer with Friends is the Highest Form of Art*. This was a social artwork. I am the author of this idea. In the '90s the idea of social interaction in an art context became an art movement.

I invited sixteen friends to the museum on a Monday when it was normally closed. Since I didn't want to subject my friends to being performers, the public was not invited. I told the curator, George Neubert, to get the beer and to be there. Everybody showed up, and we drank and had a good time. The debris was left on exhibit as a record of the event. Basically, the show consisted of the evidence of the act. It was an important work for me, because it defined Action rather than Object as art. And drinking beer was one of the things I learned in art school.

Earlier that year, in March, I had started my own museum as an excuse for a party. I was still curator of the Richmond Art Center, but I wanted to do more radical things than I could do at Richmond. I rented a large room

at 86 Third Street, south of Market Street in San Francisco. The Museum of Conceptual Art began at the start of a new decade, 1970, and continued until 1984. All the things that happened there in the first few years were actions by sculptors. I even did a show called "Actions by Sculptors for the Home Audience." It was made for KQED-TV, a PBS station, in 1974.

There were very few painters in the Conceptual era; painting was not part of the avant-garde anymore. You evolve from painting to sculpture; that's how I saw it in the '70s. My museum was for action art, actions by sculptors, and site-specific installations. The first publicly announced show was called "Sound Sculpture As." Maybe it was the first Sound Art show anywhere. A movement called Sound Art came into being later, but it did not exist in 1970. Sound was used by the Fluxus artists in the 1960s, but their sound performances were concerts. Fluxus was an irreverent international group, like the Dada artists of the '20s, with more poets and musicians than visual artists. John Cage influenced Fluxus. He was a composer, and what he did was music, not Sound Art, because his intent was music. Music has an organization based on a time signature. If somebody hammers a nail into a piece of wood, and if it's in a music context, it could be music. But if it's done by a sculptor to demonstrate the physics or materiality of sound, then it's Sound Art. In Sound Art, the sound is a sculpture material.

I invited nine sculptors to make sound works for my show, which took place on April 10, 1970. Each artist produced sounds by manipulating a material. Terry Fox hit a bowl of water against the floor and made a sound like *bong*. Paul Kos trained eight boom microphones at two twenty-five-pound blocks of ice. People listened, trying to hear the inaudible sound of the ice melting. Mel Henderson fired a thirty-caliber rifle in the room, which

had about a hundred people in it. Jim Melchert, who was out of town, gave
instructions to one of his students, Jim Pomeroy, to perform his work.
Pomeroy went to Breen's Bar and telephoned my space. He had been
instructed to let the phone ring fifteen times, then hang up, then put another
nickel in and do it again for fifteen rings. The room was filled with people lis-
tening to the telephone ring thirty times. That was a good piece.

My alter ego, Allan Fish was one of the nine artists in the show. Again,
as in Richmond, the artist sent instructions for the curator to perform the
work. I was announcing all the artists' performances as they occurred, and
I announced I would be performing Allan Fish's piece for him. I climbed to

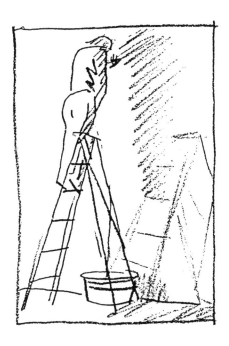

PISS PIECE

the top of a stepladder and, with my back to the audience, peed into a big galvanized tub. As the water level went up, the sound level went down. It demonstrated a principle of physics. Since my back was to the audience, it was clear that this was not about exposing myself. It was funny and shocking, but mostly funny. The audience was laughing and applauding. I was famous in San Francisco for my *Piss Piece* for about twenty years, but it's faded from memories now. Someone told me that Francis Coppola said he could never fill a bucket with water without thinking of my *Piss Piece*.

Years later, when I got to know John Cage, he told me that once when he was giving a lecture he needed to pee and wished he could have done my piss piece behind the lectern. The audience wouldn't have been able to see what was going on, but they would have heard it from the big speakers that were up there. Everybody would have had to get up and go out to the bathroom after that.

A Lenny Bruce routine: Two guys are sharing a room and one gets up in the middle of the night and is starting to pee in the sink. His roommate wakes up and says, "You're not peeing in that sink are you? I wash my face in there." The guy says, "Oh no, I was washing my leg." He still has to pee and the bathroom is way down the hall. So he goes out on the window ledge. He's up on the twelfth floor, and all of a sudden there are fire engines and a priest who says, "Don't do it my son, don't jump." He says, "I just gotta pee." Then his mother shows up and she tells the firemen, "Run the hoses, run the hoses." And the guy says, "I can't go now with all of you looking."

When I did my *Piss Piece* in the "Sound Sculpture As" show, people accepted that I was performing a piece for Allan Fish. About a year later, when I left the Richmond Art Center, I exposed my identity as Allan Fish

and no longer exhibited under that name.

In 1967 a show at the University Art Museum at Berkeley called "Air Art" was organized by a New York curator named Willoughby Sharp. He looked me up when he was in town, and later we kept in touch. After I started MOCA, he organized a video show for me called "Body Works." He got tapes from artists and sent them to me in the fall of 1970, and I decided to show them in Breen's Bar. This was the best way to see real-time tapes. You could come and go, have a drink, talk. and be comfortable. The tapes were thirty minutes each, black and white, soft focus, and with no story line. Bruce Nauman walked around his studio in an exaggerated manner; Vito Acconci burned hairs off the nipple area of his chest. William Wegmen, Terry Fox, Dennis Oppenheim, and Keith Sonnier were also part of the show. It was the first Video Art show in California, and the first show in the country to focus on Body Art. The forerunners of this kind of art were out-laws, the Viennese Action artists of the '60s. They made the most shocking performances before or since. Their work was cathartic, and reacted against a conservative, repressive Austrian society.

At the time "Body Works" was shown at MOCA, I was organizing many live performances by artists, and I was in the thick of the Performance Art world. The way a curator knows about artists is the same way people in any field know other people in that field. Artists rarely came to me and said, "I want to show you my work." But I knew about the ones I was interested in, because my situation was so specialized.

For one year, 1970, I was working at Richmond, running my museum in San Francisco and living in Marin County. So I was driving nearly every day over two bridges into three counties. I had bought a house for two thousand

down and a fourteen thousand dollar mortgage. It was in a small hippie town called Forest Knolls. My kids went to an experimental school where they could choose to be inside in class or play all day in the playground.

I was experiencing country life for the first time, and I thought I should have chickens. I built a hen house next to the garage by the small creek that ran through our property. I sent away for the chickens, and they came in the mail to the post office down the road where everyone in town picked up their mail. I had ordered two dozen baby chicks, two each of each kind offered: Rhode Island Reds, Turkey Hens, White Egg Layers, and some others, with a rooster to keep them happy. They arrived in two boxes with air holes in them, and when I opened the boxes, I saw that about half the chicks didn't survive the trip. The ones that survived grew into big chickens very quickly.

I was thinking about Sound Art, and I connected a steel wire from a tree

CHICKEN

branch by the hen house to a wooden plank that was part of a small bridge over the creek. I would strike this wire or bow it with my violin bow to make musical sounds, and the chickens would cluck and sing along. I could stand on the plank and make the sound higher as the tension increased. This was just a few months after my "Sound Sculpture" show in MOCA. I would also go deep into the woods up the street from our house with my tape recorder and record the sounds of insects and birds. That's how quiet it was in Forest Knolls.

But I'm a city boy at heart, and I didn't really move to California from Cincinnati to live in Forest Knolls. I had lost my job at Richmond in 1971, and by 1973 I was divorced and had moved into my San Francisco studio, which was a tiny room in the back of my Museum of Conceptual Art.

At that time, some critics were starting to write that Performance Art was merging all the arts together into one multimedia happening. They hadn't caught on to the idea that Happenings were over with by the mid-'60s. Performance Art, which was concrete and not decorative or theatrical, replaced Happenings.

I did a few radio interviews with artists on KPFA in the early '70s. I went to the station once at 2:30 in the afternoon with a San Francisco artist, Alf Young. In the "On the Air" studio, we sat at a table with a microphone between us. Sometime during the interview, we both decided we had to go pee. I explained to the listening audience that this was live. "It's not like you can turn off the tape recorder," I said. "We're going to be as quick as possible, but we're going to go to the restroom." There was probably a couple of minutes of dead airtime, and the show went on the air like that, because KPFA was loose. I think there is a law against dead airtime now; maybe

there was a law then.

Another time I did a show designed for the radio called "MOCA FM." I asked twenty-one artists, including a few composers, to do one-minute radio pieces. Some of them gave me tapes, and sometimes I called them up and recorded over the phone. I put the pieces together on one tape, with the names of the artists announced between the one-minute works.

Charles Amirkhanian was the music director of the station. He is a composer, and he was one of the people in my "MOCA FM" show. He had recorded one minute of steady applause, taken from a record of a famous symphony concert. When the "MOCA FM" program was broadcast, I sent out cards inviting everyone to hear it on the air at a reception in Breen's Bar. It was a packed house. People were drinking and listening to the pieces. After each piece was my voice, announcing the next artist's name. When it came time for Amirkhanian's piece, my voice said, "Charles Amirkhanian." Then you heard the applause for a minute. He stood up for the whole minute in the bar. It was very funny.

In '73 there was a show at MOCA called "All Night Sculptures," probably the most interesting show that happened there. It was very serious. Nine artists designed works for all-night viewing: installations that had something to do with nighttime or performances that went on for twelve hours from sunset to sunrise. People could come at any time during the night to see the show.

Every artist had his or her own room. Mel Henderson built his room into a corner that had a window on one side. There was no door, just a slit to look into. The room was lined with aluminum foil, and outside, visible through the window, were six searchlights aimed at the building next door,

BARBARA SMITH

which was a parking garage. He lit that building just so you would see it through this little slit. That was really an interesting way to make a space that was about the night.

There was a room in MOCA that had been a ladies' lounge when the space had been a printing company before I moved in. It was a little room where the women employees would rest or smoke or put on makeup. Barbara Smith chose that room and set it up for her performance. She put a mattress on the floor with a sheet on it. Next to it was a table with incense and oils and fruit and flowers. Barbara was naked on the bed, and a tape recorder kept playing the same thing: "Feed me, feed me, feed me," over and over again. All night, there was a line outside the door, mostly

men. A bare lightbulb was hanging outside the door. It felt like a street corner. People went in one at a time to have a private session with Barbara. They had a glass of wine or a piece of fruit with her, or had a conversation, or gave her a massage, or had sex. She took some flack from feminists later. They thought she was selling out. She didn't interpret it that way at all. She said it was about how men relate to women.

Terry Fox built a work in the skylight. You climbed up a ladder and into a little space where you were on your hands and knees under a board. After you crawled out from under the board, you realized that it had a sheet on it and was the size of a bed. The moon shining through the skylight was the only light. There was a metal bowl with a big sponge in it that had been soaked in vinegar. Terry called this piece *Memento Mori.*

Since I was the director of MOCA, I could be in the shows only if I was invisible. In this exhibition, my work was presented by another person using his own name. At the time, most people thought it was his art. Frank Youmans was a moldmaker I had met while working in a plaster shop in the '60s. I asked him to make a plaster mold of a female model and then cast it in plaster. It took him all night to do this, and the room he worked in took on the look of a traditional artist's studio. When he had finished, there was plaster on the floor and the bust of the woman was on the workbench. That piece still exists. I called it *The Artist's Studio* and the Oakland Museum bought it twenty-five years later.

By the end of 1972, I had moved MOCA into a larger space across the street at 75 Third Street. It was a nonprofit organization, and I convinced the building owner to give me the space free because I was providing a service to the community. About a year after I moved in, the San Francisco

Redevelopment Agency bought the building, and since their policy was to keep the rent the same as the tenant was paying to the former owner, they continued to give it to me free. The museum stayed in that building for twelve years.

The new MOCA was upstairs from Breen's, a historic San Francisco bar and

THE ARTIST'S STUDIO

hofbrau-style restaurant with a carved wooden back-bar that had come through the Panama Canal from Germany in the early '20s. I used a booth in front, near the street, as my office. There was a public phone on the wall next to it.

I appealed for museum members and listed the benefits: ten thousand square feet of exhibition space, seven stories of parking next door, a café

downstairs, and free beer on Wednesdays while artists' videotapes were shown. I had a refrigerator with the words *Free Beer* on the door. I bought the cheapest beer I could, supermarket beer at eighty nine cents for a six pack of short bottles of Fisher beer.

I defined Conceptual Art as "idea-oriented situations not directed at the production of static objects." In 1971 I had decided to apply for a grant from the National Endowment for the Arts in the museum category. Brian O'Doherty, the head of the visual arts department, called me and asked if what I was doing was a workshop, because the NEA had a category for that, but after talking about it we agreed that MOCA didn't fit there. (Later they had an alternative art spaces category.) So I applied for a museum grant.

O'Doherty told me that if I wanted a grant for MOCA, I should get letters of recommendation from three people he respected in the Bay Area: Jim Melchert, Peter Voulkos, and John Fitzgibbons. I knew the first two people already. Melchert had been in my Sound Art show; he was also a professor at U.C. Berkeley. Voulkos was a famous ceramic sculptor. They both wrote letters for me. I did not know Fitzgibbons, who was an art critic who taught at Sacramento State College. I called him and offered to come for free to his class and talk about MOCA and my work. That way, he would know what I did and could write the letter if he wanted to.

When I got to the art building in Sacramento and was walking down the hall, I looked into one of the classrooms and saw rows of cooking stoves, countertops, sinks, and refrigerators. I thought this must be the most advanced art department in the world. It turned out to be the home economics department, which was across the hall from the art department. But the experience planted a seed in my mind about the future of

art. In 1978 I wrote a list of predictions for an art conference, and one of them was that cooking would be taught in art schools. It hasn't come true yet as far as I know.

I got the NEA grant. It was five thousand dollars, and it was the entire annual budget for the museum in 1973. That's the reason I was able to move MOCA into the larger space across the street.

It's a good thing that I was never noticed by Senator Proxmire who gave what he called the Golden Fleece Awards to organizations he thought were ripping off the government. One award went to a private science agency that had received a small grant for the study of the sex life of the tsetse fly. At the time, people thought this project was funny and useless. Why should the government fund the study of the sex life of an insect? It turned out that the best way to control insects is to understand how they reproduce.

SEX LIFE

Instead of trying to poison them it's better to make them sterile, and to know how to do that you study their sex life. It was serious research.

The NEA gave grants to many artists that Senator Proxmire would have questioned, but artists advance our culture in the world. I didn't take Robert Mapplethorpe's "dirty" pictures very seriously, but he launched a

homosexual movement into the art mainstream. In the '90s, Senator Jesse Helms used Mapplethorpe's pictures to get individual artists' grants eliminated from the NEA program.

The "reality" programs that are on TV now were predicted by works of Performance Art in the '70s. Back then, a lot of artists were interested in endurance works. Eleanor Antin went on a diet, took pictures of her naked body every day, and lost thirty pounds. That was an endurance piece.

In 1973 Linda Montano came to me with the idea that she and I would be handcuffed together for three days. It was her work, and I was a participant in her piece. At the opening we showed a video that was half an hour long. Videotapes were reel to reel in those days and thirty minutes long. I had a video recorder that was like a big trunk, and sometime during each day or evening I would turn the camera on and record ten minutes straight without stopping. One day we ate dinner during a ten-minute segment. In another segment we walked around. We were doing normal things that anyone would do, but we could only show things we did in MOCA because the video recorder was so heavy. The video was just to get a record of some of our activities. It wasn't the point of the piece. While we were handcuffed, we rode on the bus, went out to eat, went to the movies, went to the hardware store, in other words had a life.

Although there wasn't an audience, it felt like a performance for three days. I thought of the marathon dances of the '20s where the last couple standing won the prize. It seemed like a dance because we had to move in sync, in unison, like ballroom dancers, to turn, navigate, sleep, walk, and sit down.

When I was handcuffed to Linda, she was married. I didn't know her very well. We were just colleagues. My left hand was handcuffed to her right

hand. You cannot imagine the actual experience. Twenty-five years later a female art student accused me of abusing Linda Montano by handcuffing her to me. Because we are living in politically correct times, the student made the assumption that I took advantage of this defenseless woman.

There were only a few women performance artists in the Bay Area at that time. Linda Montano had been a nun before she became an artist. In her work, she would take roles. At Christmas she was a Salvation Army bell ringer. She took the real job and made it into art by documenting it and putting it into an art context. Many women artists in those days in both Europe and America assumed roles as art-life situations. They would approach Performance Art like street theater, playing a role in the real world. In San Francisco, Linda Montano and Bonnie Sherk were the two most visible women working like this.

Bonnie Sherk started an alternative art space called The Farm. It was in a building under the freeway with a yard. She grew plants and kept animals there, like a mini-farm. At the same time, she worked in a restaurant wearing a big bouffant wig. This was her real job, as a waitress in a clam house in San Francisco. But she did it as an art piece and had herself photographed in her costume. Eventually, both Bonnie Sherk and Linda Montano moved to New York.

In 1983-84, Linda Montano was tied with a rope to another artist, Tching Hsieh, for one year. The rope was eight or ten feet long, tied around their waists. They never took it off, but slept in separate beds. It was a collaboration, half her piece and half his piece. He had already done several yearlong confinement pieces, and this was another one. I think Linda was redoing her handcuff piece as penance, acting like an ex-nun

on her way to salvation. I guess they worked this out together. They ended up not liking each other.

Tching Hsieh came into the art scene in the '80s after endurance art had been developed for a decade. He is obsessed with making his life into his art. He punched a time clock every hour for a whole year, not sleeping for more than one hour at a time. He lived outdoors for a year, on the street like a homeless person. He lived in a cell for a year. The punishments that he imposes on himself are extreme versions of endurance art, and are a type of antisocial behavior that could be a textbook example for the psychiatric profession. For me, Action Art is social and is about communication.

In 1971, I did an endurance piece in an art gallery in San Francisco. It was called *Allan Fish Drinks a Case of Beer*. That piece had its roots in my art school days. Back then, when a guy who said he couldn't afford much wanted to buy one of my paintings, I offered to trade the painting for a case of beer. When I gave him the painting he said, "Here's the money for the case of beer," and handed me $5. He even wanted change because a case of beer cost $4.75. This bugged me for years. I had thought that the painting would be worth the experience of getting drunk off a case of beer, because that was an experience you'd remember the rest of your life. But I wanted to barter the painting for the experience, not have money come in between. Of course, in the '50s I didn't know what Conceptual Art was. It wasn't a movement then. But I was starting to think about art as experience. I did go out and buy a case of beer with the money, and I drank it in one day. I was twenty-one at the time.

Thirteen years later when I did the *Allan Fish Drinks a Case of Beer* piece, I tried to drink the whole case, but I only got as far as seventeen bottles. The

bottles are a record of the act, seventeen empty Beck's beer bottles upside down in a wooden case that has twenty four slots. I cheated, because two of the bottles were drunk by Howard Fried and Terry Fox, friends who showed up in the afternoon. I signed the bottles I drank and they signed theirs too.

I started at noon and finished at 8 p.m. It turned out that the piece was about creating an art situation that changed as I became more inebriated and that influenced my aesthetic decisions. The piece had the character of jazz, which is a structure for improvisation. I had a refrigerator in the gallery, a comfortable chair, my conga drum, and other things I thought I would need. My hat and coat were hanging up on the wall. As the show progressed, I arranged the room and made an environment. I ran threads across the room to create a barrier between the public and me. The opening was from 6 to 8, and I was already drunk by the time it began. At the open-

HAT AND COAT

ing I drew some lines on my face. My face looked like a Picasso, or a Futurist painting, like I was moving: three noses going off to the side, an extra eye on my temple, and my mouth made wider. I had a radio, a record player, and a tape recorder going, and I was playing the conga drum. Later I changed the title of the piece to *The Creation of a Situation and Environment while Becoming Increasingly More Intoxicated.*

Another beer piece (1976) took longer to do. I drank a bottle of beer from a different country each day and placed the empty bottles on a long shelf. The work became a world map in beer bottles that I called *From China to Czechoslovakia.* In 1973 in my Museum of Conceptual Art I had a refrigerator filled with free beer and each Wednesday people watched Video Art and drank beer. I put the empty bottles for that whole year on a long shelf.

FUTURIST FACE

CHINA TO CZECHOSLOVAKIA

Someone asked me this question: "How can you have a Museum of Conceptual Art? Is it a real place, or is it in your head?" My answer was that it was a real place, with a collection and a café. When the building was torn down in '84, most of the collection had to go down with it because the collection consisted of relics and residue from actions that were designed for and occurred in that museum. There were chairs hung upside down on the ceiling, part of Vito Acconci's first work in California. There was an installation in a skylight shaft by Terry Fox. This kind of work was impossible to remove from the building, because without context it no longer could be recognized as art.

I am fascinated by art that can only be seen if you know it is art. If something that's not painting or sculpture seems interesting and is in an art context it might be a work of invisible art. For instance, in 1970 Robert Barry had an exhibition that was a completely empty gallery with just one label on the wall, a regular label like you would see on any work of art. It said, "FM radio waves running north to south 18 inches down from the

ceiling and 18 inches in from each of the four walls." You could imagine the radio waves running lengthwise in the gallery. They were invisible, but with language Barry created his piece in your mind.

You can probably see the ideas behind an artwork that seems to be invisible if you look for more than just a few seconds. You can try to figure out the artist's intention, and usually you have a clue from the title. If you stay with it, eventually you get most of the story. You never get it all. The artist doesn't get it all either, and may get something unexpected after he steps back from the work when it is finished. Different people get different information, depending on what they bring to an art work. If you go to an Italian opera and you don't understand Italian, you don't get the whole story, but you still get a lot out of the opera. It's like that in every field. When a scientist looks in a microscope, he might see a cure for cancer. If I looked in the same microscope, I would see an Abstract Expressionist painting. A frog can see only bite-sized moving objects, insects, for instance. Its brain blocks out everything else. Sometimes people don't know what they are looking at because their brains block out everything except what they expect art to be.

In 1974 the San Francisco Redevelopment Agency, my landlord, gave the floor above my museum to another nonprofit organization, the Chinese Youth Alternative. In Chinatown there were two main gangs at the time. One was for American born Chinese, and the other, the Wa Ching, was for Hong Kong born. The Wa Ching were my new neighbors. After six months of gang warfare in the building these juvenile delinquents were evicted and I got back the third floor, which I had been using before this group moved in. The walls were full of holes and covered with English and Chinese graffiti.

There was broken furniture everywhere. It looked like the place had been bombed. I sent out an announcement, with a picture, inviting people to a one-day viewing of an environmental exhibition by the Chinese Youth Alternative. This was an invisible work of mine. I claimed the space and presented it as a work of art. It was a ready-made installation, a piece of real life that became art in the context of an art museum.

I believe in making art out of misfortune. I had a brass plaque made and put on my front door. It read "Breaking and Entering, March 5, 1975." I thought this would be a deterrent to crime, since my space was always being broken into, but the plaque was stolen.

I made an electric sign that said "Private Investigation" and hung it in my window, and some people in the neighborhood thought I was a real private eye. That was also intended as a deterrent to crime, but the criminals didn't read. The sign was an artwork for me. Artists are private investigators and trained observers.

In 1975 I did a show called "Second Generation" with artists who had been students of the artists of my generation. One of the artists painted a large section of the back wall, ceiling, and floor white to set up a space for his performance. After the show, I could see that this white section interfered with the character of the space, which had been a printing company for fifty years before I moved in. Being concerned with traditional museum functions like preservation, collection, and restoration, I thought of the space as a relic of the mechanical age.

I got the idea to restore the back wall area of MOCA when I read about the restoration of *The Night Watch*, a painting by Rembrandt that had been slashed in the Rijksmuseum in Amsterdam. They built a special room in the

museum with windows around it so the public could watch the restoration like sidewalk spectators.

Up until that time, 1976, there had never been a painting show in MOCA. I asked a painter friend of mine, David Ireland, if he wanted to collaborate with me to fix the space. Working every day for a month, he scraped the white paint off the floor and rubbed it with printers' ink to stain

THE BACK WALL OF MOCA

it back to the original color. He worked from photographs to match the colors and restore painted shapes that had been on the wall where the printing company had painted around equipment. He replaced the moldings that had been cut away. Each day I would videotape the progress, a kind of time-lapse photography. We were making a Photorealist painting, and when the work was done there was a completely invisible artwork. David Ireland later became one of my best friends and a well-known Conceptual artist.

For a couple of years in 1973 and 1974 every Wednesday afternoon there was free beer in MOCA while artists' videotapes were shown. In '76 I decided to meet people downstairs in Breen's Café, and I sent out cards announcing *Café Society* "twotofour" every Wednesday in the "saloon of MOCA." I got the name from Bob Feldman, a New York publisher. I had just done a one-page photo work for *San Francisco Magazine* that said, "There is meaning in life only if you devote yourself to society," and when Feldman saw it he said, "café society."

I went down to Breen's every Wednesday, sat there, and drank a beer. In the afternoon Breen's wasn't busy, and we took over the booths in the front of the bar. Later, the booths were reserved for us. Over the years, the meeting time has gotten later. Now, it's in my studio and is from five to eight.

My *Café Society* became a kind of open house for artists, an artists' bar, really. In New York, a lot of artists were living in the same neighborhood, SoHo, which had bars where they hung out. But the only way to get an artists' scene going in San Francisco was to do it in an artificial way, by formalizing it, by inviting people.

This is a social artwork for me, another kind of invisible work. When Breen's closed in '79, I moved to the bar next door, Jerry & Johnny's. In 1980, I printed artists' credit cards and gave one to any artist who asked for it. The artist would show the card to the bartender in order to get free beer. The money for this came from a grant to SITE, Inc., an alternative art space run by a friend of mine, Alan Scarritt. He had closed his space on Mission Street and moved to New York without using up a grant he had received, so he turned over one thousand dollars of it to me. At that point I wasn't receiving NEA grants anymore. I was too elitist for them. I was not an arm of the

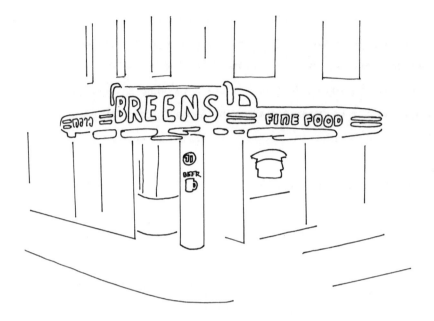

SALOON OF MOCA

government with a multicultural board of advisors. They were on to me.

In 1984 I closed MOCA. I lost the building, but also it was the end of an era, and I hadn't done any shows since 1981. Conceptual Art has come back now, but it was dead in the '80s. Art schools were starting to have Conceptual Art departments. It had become an academy. After MOCA officially closed, I changed the name of my meetings to "Academy of MOCA." My meetings were an academy like in the time of Aristotle, basically a bunch of people hanging out, drinking, and having conversations. When I first started the meetings, I was trying to re-create the feel of the Paris café scene in the 1920s where artists and writers met each other. I

thought café society meant drunken parties where ideas are born.

I always wanted to be legitimate, to carry on traditions, and at the same time to get away with something. That was why I started a museum in the first place. With my own academy, I was in a position where I didn't have to get a degree from anybody. I was in a position, actually, to give a degree to somebody. Today I give GB (Graduate Bartender) degrees to guest bartenders who sign up three times to tend bar on Wednesdays.

This document declares that

has successfully completed
the guest bartender course
for the Cafe Wednesday
artists salon, a division of
MOCA (Museum of Conceptual Art)
1970-1984 and is hereby awarded
the title of GB

GB DEGREE

The Academy of MOCA met at Jerry & Johnny's for ten years until the '89 earthquake in San Francisco closed it permanently. I was without a hangout for about six months, but temporary Wednesdays continued first in the House of Shields bar a block away and later at the Capp Street Project, an art space where I had an exhibition. Then I got a new studio. There was no bar downstairs, so I built one in my studio.

For two years, 1990-92, until the Berkeley Art Museum at the University of California bought my archives, I called my Wednesday meetings "Archives of MOCA," and after that I switched to calling it "Café Wednesday." As of 2000 it is called the Society of Independent Artists, SIA, which was the name of the organization that exhibited Duchamp's famous urinal in 1917. Over the years, I have exhibited several social art installations that included bars activated on Wednesdays. My Wednesdays have evolved over the years into a kind of salon. One of the original salons was started by Madame de Rambouillet in eighteenth-century France in order to have discourse that allowed men and woman to talk to one another on an equal basis. The concept of the opera was invented in Florence, Italy, by a group of musicians, artists, and writers, a club called the Camerata. Sometimes I tell people I have an Italian social club and I'm the only Italian in it.

Café Wednesday has become by necessity a private club. People bring their own drinks. I had to establish house rules:

People bring their own drinks except first timers who don't know any better.

Two-drink minimum; this means at least two. I don't want people to pop in and have a quick drink, or maybe not even have a drink. I don't want them to come with the idea that they'll look over the situation and then maybe split. I want people to know where they are. One time there was a

TECATE BEER

woman who came as a guest of a guest and then started bringing her lonely friends. They would just sit, like they were watching a play. They wouldn't drink, and they wouldn't talk. Finally, I said to her, "I'm trying to project an air of sophistication here. I'm not running a mission."

No beer in cans except Tecate. I think it is elegant to have glass bottles. Glass is a more noble material than a tin can. Also, people tend to drink directly out of cans, because a can is shaped like a glass. They might not as readily drink directly out of a bottle. The exception for Tecate is because it is traditionally served with a slice of lemon, and I think this beer actually tastes better out of the can, with the lemon and the metallic taste. Lemon brings out the taste of most things. You can even put a piece of lemon in a Budweiser and it tastes pretty good. And I like the way the lemon looks. Tecate shouldn't be confused with Corona, when it is served with a little wedge of lime. That was a yuppie fad in the '80s.

No drinking from beer bottles except in character. It is not dignified to drink directly out of the bottle. Like the Hennie Youngman joke, "My mother is ninety two years old, never uses glasses. Drinks straight out of the bottle." The exception for character is an acknowledgment of individual style. For instance, a cowboy would drink out of a bottle, never use a glass.

No use of telephone except with consent. That's so people won't take me for granted and think I'm just a public place, a service paid for with a government grant. Those days are gone for good.

No one behind the bar except the bartender.

Bartenders can invite up to three guests. Joyce Umamoto was the permanent bartender for the first five years we met in my studio, and since she "retired" I have had guest bartenders who sign up in advance. The bartenders can invite three guests so they participate by making it partly their own party. That is also a way for me to meet some interesting new people.

Guests do not invite guests without checking with the management. Three obnoxious people can come into a party of twelve and ruin everything. People coming into this scene should be sympathetic to the situation. This is an artists' club. I told one guy who was bugging me not to come back. He didn't know who Sol LeWitt was. If you don't know who Sol LeWitt is, you can't come in.

No theater people except famous movie stars. Theater people are too theatrical. The exception for movie stars is because they are celebrities not theater people.

No art students except those who can pass as professionals. Once a guy showed up in Breen's Bar with his class. There were only enough places for eight or ten people, and he showed up with about ten. They all sat as if they

were in class waiting for somebody to teach them. The exception is because sometimes art students are smart and interesting. It could happen.

No smoking, except writers and cigar smokers. The exception for writers is to allow some smokers but limit the number. It has been abused. Anyone can claim to be a writer who can type. The exception for cigar smokers is because cigars are not inhaled and are not intended to be a nicotine delivery system. The experience is about taste and aroma. It enhances a social situation and becomes an aid to communication. Cigarettes use cheaper tobacco and also burn paper, creating an offensive smell. Cigar smoke, like gasoline, can create nostalgia, like memories of childhood sitting in the back seat of your family car gassing up on a trip to Syracuse, New York. The smell of a cigar, for instance, reminds Lydia of her grandfather. The rule prohibiting cigarettes should not be taken as discriminatory against women.

No touching objects or books on shelves.

No art collectors except in disguise. I know the way some artists act around art collectors. I've been guilty myself of kissing up to them, but not

CIGAR

enough to actually sell my work. Some collectors get used to artists kissing up to them and take advantage of that. They say they are art collectors as if that were a profession. An art collector is in disguise if he doesn't announce he's an art collector. I don't want my friends to embarrass themselves kissing up in front of others, which is what they should be doing in private.

People should sign the guest book at the bar. The guest book is to keep a record. People like to know who came the week before. Like in a mystery novel, if you want to commit a crime, you could sign in, leave, murder somebody, and be back before closing time.

Hours 5-8, except on special occasions. Like when everyone is having "such a good time."

Leave the bathroom light on.

1972

During the '70s when MOCA was most active, I began to get invitations to make works in Europe. There were a lot of opportunities for American

BATHROOM LIGHT

artists of my generation to travel to Europe and meet European artists. World War II had wiped out the art world in Europe and Britain. Before that, most of the great artists were in Europe but after the war New York was the art center of the world. Artists who lived in New York also showed in Europe, but European artists in general did not show in America.

Europe continued to look to America in the '60s, with Pop and Minimal Art. In the '70s, Conceptual Art was worldwide, and Europeans were interested in American Conceptual Art as well as their own. When the '80s came around, European economies had become stronger, and their governments were supporting their artists. Then there was a kind of backlash against American art.

My first trip abroad was to Edinburgh, Scotland, in 1972. One day in San Francisco I got a phone call from an Edinburgh gallery owner named Richard Demarco. He was on his way out of town. He called me from the airport. He had visited the Oakland Museum and asked the curator, George Neubert, who the craziest interesting artist in San Francisco was. Neubert gave him my name and phone number. Demarco asked me if I would send him some information about my work. I did, and he invited me to come and make an exhibition in his gallery in Edinburgh. His gallery was the hippest gallery in Scotland at that time.

When I went there in '72, I did a five-day performance. I did action drawings that produced sounds, a different drawing each day for four days. On one day I did not draw, but created an art situation.

On the first day, a Thursday, I made my first drum brush drawing. I am still making these drawings today. They are the result of rubbing and beating against large sheets of sandpaper with steel wire drum brushes, like jazz

drummers use. The action is repetitive and makes a rhythmic, rasping sound. As I drum over a long period of time, steel from the brushes is transferred to the paper to make a drawing that reminds some people of the shadow of a bird flying. It is a pictorial record of the sound activity, which can produce a trancelike or meditative state in me and in some members of the audience. As I have continued to make these drawings over the years, they have changed only slightly, like handwriting changes as personality evolves.

The next day, Friday, I made a drawing called *Drawing a Line as Far as I Can Reach.* I hung a long scroll of tracing paper on the wall so it continued

DRAWING A LINE AS FAR AS I CAN REACH

onto the floor. Then I stood in my socks on the paper and drew lines over and over, each time starting the line by reaching back between my legs as far as I could, continuing it along the paper on the floor, and then reaching up the wall as far as I could. A microphone under the paper amplified the sound as the pencil approached the wall, and as it moved upward the sound diminished. It was like the sound of the sea coming in and going out. Doing this drawing was like doing yoga while holding a pencil.

Saturday was the day I did not draw. It turned out that the biggest soccer game of the year was on that day. The game was between England and Scotland. I asked if the gallery could get me a refrigerator and a color TV. Color television was brand-new in Scotland at that time, but they managed to get one. I put the refrigerator at one end of the gallery, filled it up with beer, and printed the words *Free Beer* on it. At the other end, I had the color TV set, and the game was on. That gave me the idea for my free beer with artists' videos that I began doing in MOCA a year later.

The performance I did on Sunday was called *Sunday Scottish Landscape.* I placed a piece of brown paper between the strings and the body of a violin so the paper hung down like wings, and I played a single harmonic note for about half an hour. It was a very eerie sound, just this one continuous high- frequency sound.

The white powder from the rosin on the bow made a diffused white mark on the paper. I had covered one eye with a cloth and with the other I zeroed in on the bridge of the violin, the strings, and the rosin. I was imagining that the strings were like telephone wires and the wooden bridge was a real bridge. The rosin was the mist—it's very misty in Scotland. And the brown paper was the land.

VIOLIN BIRD

From my perspective, up close, with my chin right down there against the violin, I was seeing this miniature scene, the *Sunday Scottish Landscape*. From somebody else's point of view, I was holding an instrument that looked like a bird. As I bowed, the violin moved up and down slightly, and the wings flapped a bit. Then later, I hung the violin up by a wire and made a mobile out of it and called it *Violin Bird*. I used a spotlight to make a shadow that had a poetic relationship with the object, a bird on the wind.

On Monday, the last day of my series of performances in Edinburgh, I pinned a piece of drawing paper on the wall and placed a boom microphone on a stand close to the paper. Then I struck the paper with a heavy steel wire, and the microphone began to create feedback. I could control the pitch of the sound by moving my body back and forth. It sounded like the paper was screaming with pain.

Every year during the Edinburgh Festival Richard Demarco organized a show of artists from a different country. In 1970, he had done the German

artist, including Joseph Beuys, the most original European postwar artist. Demarco's gallery was the first in Great Britain to show Beuys.

Demarco explained to me how he was able to go to countries and find the best artists. When I met him in 1972, he had just been to Yugoslavia. He said that when he went to Belgrade, the first thing he did was to go to the Fine Arts Academy. They, of course, showed him around. He met artists

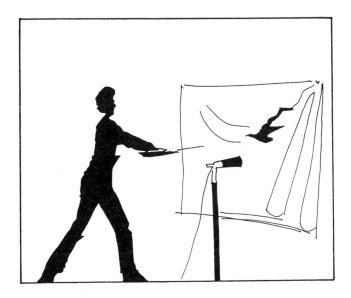

FEEDBACK

who were doing safe abstract painting, the kind of painting the government allowed. Demarco was doing what the curators from the Whitney Museum did whenever they would organize their biennial exhibits. In San Francisco, they would go to the Art Institute. The difference was that the Whitney curators invited the artists they were shown, and Demarco didn't. After

looking at the establishment artists, he said, "Are there any crazy artists in Belgrade who aren't even really artists?"

The guy at the academy said that there were some over at the Student Cultural Center, which was in an old police station. There had been a student revolt, and after that the city gave it to the students to use. In it they had a gallery, a theater, a bookstore, and a café. It was there that Demarco discovered the most interesting artists in the country, including Marina Abramovic.

In Demarco's gallery in Edinburgh in 1973 she did an intense performance in which she laid her left hand on the floor and, holding a knife in her right hand, rhythmically jabbed it between her spread fingers. Whenever she cut herself, she would stop, pick up another knife, and begin again. At the same time, several other artists were performing in the same space. Rasa Todosijevic painted his left ear and the leaves of a potted plant, while his wife held up a sign that said, "Decision as Art." Gergelj Urkom upholstered a chair by cutting up his shirt and tacking it to the chair. And there were others. It was like a three-ring circus.

These artists were part of the new avant-garde of Eastern European political art. Their exhibition in 1973 at Demarco's gallery took place during the Edinburgh Festival, and since Demarco brought me back for the festival that year, I met them. He also brought back Joseph Beuys, so I met him too.

At that time, I had a band, called the MOCA Ensemble. We played free jazz. There was a drummer, a tenor sax player, and a synthesizer player. I was a second percussionist. Sometimes in groups there will be two of the instrument the leader plays, in order to emphasize that instrument. In Edinburgh, I set up a room in a school around the corner from the gallery and made it into a club. Every night for several nights there was free beer

and we played jazz. People came and hung out.

I asked Demarco if he could set up an appointment for me at St. Mary's Cathedral, the largest cathedral in Edinburgh. He arranged an appointment with the bishop. I told him my group played sacred music, and said I would like to have a concert in the cathedral. The bishop said, "Oh, all right, that sounds fine."

Announcement cards were printed and mailed out and a lot of people came. The custodian said he was worried that people would get "their sweetie pies all over the seats," and afterward the bishop said, "If I told you I enjoyed it, I'd be lying." But everyone was polite. I guess I thought this was

ST. MARY'S

my chance to be an altar boy and also raise hell. I was all in white and knelt on a little kneeler in profile to the audience. I covered my conga drum in a white cloth, kind of like a skirt. It was really wild.

The next day in the school, in a big meeting room, Joseph Beuys gave a twelve-hour lecture. It was amazing. He never seemed to leave the room. He didn't eat or drink. I came and went a few times for breaks, but I never saw him leave or take a break. He just went on talking for twelve hours. He drew and wrote on three blackboards as he talked. He read from a book, and he had discussions with the audience. He talked about socialism, the Green Party (he was one of the founders), and that everyone could be an artist. He spoke in English, but some of what he said was over my head. He used the blackboards to make notes and drawings—beautiful drawings—that demonstrated his ideas. The blackboards became works of art and were saved.

A guy named Arnold Herstand bought them. He knew this was one piece, a triptych. But I found out later that he broke up the set and sold the blackboards separately because he could make more money that way. I thought that was pretty sleazy.

Herstand had been director of an art school in Minneapolis, and later he was a private dealer in New York. In 1974, the San Francisco Art Institute hired him to be president of the school. I was invited to a party for him when he was in town being interviewed. He had on white shoes and a white belt, like he thought he was in Florida. Everything about him was wrong. I said to the party's host, who was on the Institute board, "I don't think it's a good idea to hire Arnold Herstand." He said, "Too late, we hired him yesterday." He was there for about five years.

The San Francisco Art Institute had an exhibition every year that was

important to the community because artists curated it. It was called the Art Institute Annual, and it was usually a month-long exhibition. In 1976 it was literally an annual. I organized it that year and I invited six other artists to act as curators. We took turns inviting artists, and each invited artist put up a show for a week in a rented storefront space on Sixteenth Street. The shows opened on Friday evenings. On one of those Fridays, when you arrived, you found that Masashi Matsumoto had boarded up the front door to the space with planks of wood. About eighteen inches up from the sidewalk, there was a space between two planks, and spray painted above it were the words "The Four Noble Truths," with an arrow pointing down toward the space. If you knelt down to look between the planks, you could

MASASHI MATSUMOTO

see inside the gallery. You could see that on the far wall a small piece of paper was held up with a piece of masking tape. On it were four sentences written in black ink. The paper was just far enough away so that you could not read the sentences.

The recession of the 1970s was a vital time for art in San Francisco because of the many artist-run alternative art spaces that had appeared beginning in 1972, a couple of years after I started MOCA. The most promi-nent were The Farm, SITE, Project Artaud, 80 Langton Street, the Floating Museum, and La Mamelle. In those days, alternative art spaces were artist-run spaces that showed mostly Conceptual Art. The spaces were the alter-native to the museums and galleries.

Galleries didn't want to show Conceptual Art because nobody would buy it then. Museums are tied into the galleries, so they didn't show it, except (in New York) for an occasional survey show. Museum boards are made up of art collectors, who buy their art from galleries. The galleries advertise in art mag-azines, and the magazines write about the art in galleries. The art that is writ-ten about gets collected, and the trustees influence the museums to exhibit the work of the artists they collect. The museums give that art the seal of approval, and then it increases in value. It's a circular system. The trustees usually hire a director raised in private schools with an Ivy League back-ground. The trustees are the ones who build the museums and pay for them.

Conceptual Art had no commercial value then, but it was moral and political, and because of that, it was very vital. There wasn't much art busi-ness being done in San Francisco in the '70s, but there was a swinging art

scene. Even galleries were fun in those days. Diana Fuller's gallery had the best openings. Openings were the hippest scene in San Francisco. That was where you went to get free drinks and pick up girls. Since the late '70s, I've been in a gallery owned by Paule Anglim, who shows hard-to-sell Conceptual artists and San Francisco artists of the '50s, along with some hot new artists from elsewhere. Paule also gives public service with poetry readings and booksignings, and dinner parties so artists can meet new curators or art workers taking up positions here.

In the early '70s, I had a used 750 Italian Fiat that I had gotten from the University of Santa Clara, a Catholic university. Lydia Modi-Vitale, who was director of the gallery there, had invited me to have a show, and I bought the Fiat with the money budgeted for the exhibition. That was the show, the car. I needed a car, and I thought this was a way for the church to support an artist as it did during the Italian Renaissance. I parked the Fiat in the gallery, and at the opening I sat in it and talked to people out the window. The next day, the president of the university closed the show. I kept the car.

I called the piece *My First Car* as a parody on the title of a handmade remote-controlled car built as a sculpture object by a San Francisco artist named Don Potts. I used the same title as he did, but his car was highly crafted and I just went out and bought mine. I was doing a Conceptual *My First Car* and, as Marshall McLuhan said, "Art is anything you can get away with."

Terry Fox had a French Deux Cheveaux that he had shipped back from Paris, where he had lived in the '60s. Our cars were equally matched in terms of drag racing. They were both like toy cars and we would drag race

MY FIRST CAR

through town from one opening to the other. Then we would go back to our studios and work late on our own art.

Terry was doing work based on an energy idea, like baked bread, candles burning, heat and light—art with basic elements. He was also making drone sound works. On several occasions we collaborated on performances, his droning and my drum brushing. I was making drum brush drawings, my rhythmic meditation drawings with sound. When Terry and I performed together, it sounded like the "machine music" that was developed in Europe later in the '70s.

We were part of an underground scene. It was mostly invisible to the art establishment, which at that time included the San Francisco Museum of Art and the San Francisco Art Institute. Back in the '40s, those institutions had put San Francisco on the art map.

In 1949, when Douglas MacAgy ran the California School of Fine Arts (which became the Art Institute later), there was a conference on the arts that included Frank Lloyd Wright and Marcel Duchamp among other impor-

tant people. While Duchamp was in town, he visited the school on a day when there were no classes. William Morehouse, who was a student there then, was working in a studio that day. Duchamp asked him what he was doing, and he said, "I don't know." Duchamp said, "Keep up the good work." MacAgy wanted to ask Duchamp if he would consider teaching at the school, but the faculty had a meeting and decided against inviting him. He wouldn't have accepted anyway. He was a giant in the art world.

Jackson Pollock had his first museum one-man show at the San Francisco Museum of Art in 1945. The museum bought a painting (*Guardians of the Secret*, 1943) from that show. It was the first Pollock painting bought by an art museum anywhere in the world. Grace Morley was the director of the San Francisco Museum of Art at that time. The museum was across the street from City Hall on Van Ness Avenue in the War Memorial Building, the same building where the United Nations had its first meeting when Harry Truman was president. The museum was on the fourth floor for years. Later they got the third floor also, and used it for offices and to exhibit photography in the hallways.

The San Francisco Museum of Art has never been a city museum. It is privately funded. Morley was director until 1958. From '58 to '66 George Culler was director (I can't remember anything he did), and after that Gerald Nordland was appointed. He was originally a lawyer. He was from Washington, D.C., and he was very interested in what was known as the Washington School: Kenneth Noland and Morris Louis. They were the second-generation Abstract Expressionists that came along in the late '50s. Helen Frankenthaler was part of that movement but she wasn't from Washington. That movement was also called Post-Painterly Abstraction.

Nordland did several shows at the San Francisco Museum of this kind of abstract color-field art. That was his taste. Some of the Bay Area Figurative and Funk artists also had shows at that time. Throughout the '60s, the museum ignored what was going on in New York, Pop Art and Minimal Art. Nordland's swan song came in '71 when he organized a show of Paul Jenkins, a decorative abstract painter, the LeRoy Nieman of his day. It was an embarrassment, and I assumed that was why the board fired Nordland.

A year and a half went by, and they were still looking for a director for the museum. I was hoping they might consider somebody a little more radical than the usual choices, and I got the idea to make an announcement card saying that I was appointed director. Relative to me, for that job, anyone would have been conservative.

In January 1973, I mailed the card out to the art community and to *Museum News,* a trade magazine, which published the news under "New Appointments." I was somewhat known in the museum world because I had been curator of the Richmond Art Center and had done some shows that got attention. And some people knew that I had started the Museum of Conceptual Art, which was already in its third year. So, I guess my card was not unbelievable. When William Wiley received it, my brother Paul was with him, and Wiley became very excited, saying how great this would be for San Francisco. But Paul said, "I don't think it's true. I know my brother."

I heard later that the trustees were calling each other, saying, "How come you hired somebody without telling me?" The art critic for the *San Francisco Chronicle,* Alfred Frankenstein, wrote that there ought to be a limit to the pranks that a Conceptual artist can pull. Twenty-six years later a collector bought one of the cards from me and gave it to the

museum for its collection.

Shortly after I sent out the card, they really did hire a director. It was Henry Hopkins. He had been a curator at the L.A. County Museum in the '60s. Then he went to Texas and was director of some museum there—I think Fort Worth—before he was invited to come to San Francisco. He had no idea what was going on here because he was such an L.A. person. There is a bigger gap between Northern and Southern California than the rest of the world realizes.

Hopkins brought two good shows of L.A. art to San Francisco: Bob Irwin and Ed Ruscha. In 1979, during Hopkins's time as director, Suzanne Foley (who had been curator of the museum since before he had arrived) organized a show of Bay Area Conceptual Art of the '70s, called "Space/Time/Sound." The board and the director hated it, and Sue Foley left the museum soon afterward.

One show that Hopkins did was by Issey Miyake, a Japanese clothes designer. There were mannequins in clothes hanging from the ceiling, a designer's idea of a sculpture installation. In 2001, the Guggenheim Museum did a show of Giorgio Armani. Armani gave the museum $5 million and spent another $5 million advertising it. Armani bought the show. Maybe Henry Hopkins was ahead of his time.

Usually our museum directors last about ten years and then the board gets tired of them and they leave or get fired. Hopkins left in 1984 and ended up as director of the UCLA art gallery. He replaced Gerald Nordland, who had also gone there after being director here for ten years.

In 1973 at the University Art Museum at Berkeley I made a demonstration about intention. I called it a "lecture/demonstration" because I meant it to be instructional. I outlined a square area with masking tape on the floor of the museum's central open space. People watched from above. I had my band at that time, the MOCA Ensemble, and for the first part of the piece they played bebop jazz. While they played, the janitor of the museum, the real janitor, swept the floor with sweeping compound. He did the job of getting the floor clean.

Next, a dancer swept the floor with the same broom while the band played a jazz waltz. She put feathers on the floor first, and children ran through them while she was sweeping. She was interested in the grace of the body moving through space.

After she finished, an actor swept the floor, using the same broom. The band played movie soundtrack music. He swept the floor with a flourish, playing to the audience, always facing the audience, like he would on a stage. He was concerned with convincing the audience that he was a janitor. It didn't matter to him whether he got the floor clean. He was less concerned about the grace of his body than about playing the role and being convincing.

I was the last one to sweep the floor. The music was free jazz. I used sand, a sculpture material, and gave the floor an even coating. As I swept, I made patterns, manipulating the material. That was my concern, moving the material.

When the janitor swept the floor, it was real life. When the dancer swept the floor, it was dance. When the actor swept the floor, it was theater. And when I swept the floor, it was sculpture, a sculpture action. The same activity was different, depending on the intent of the person doing it.

1974

Nineteen seventy-four was a good year. That was the year I met my future wife, Kathan Brown: artist, writer, teacher, and printmaker. We met at a party for painter Dorothea Rockburne, who was visiting from New York. Later that month I saw Kathan at an opening at the San Francisco Museum of Art and asked her for a ride home in her racing-green sports car. She invited me to talk to her printmaking students at the Art Institute, and that led to an invitation to make a print at her Crown Point Press.

I proposed that we print labels for a special edition of bottles of beer. I think this was too radical an idea even for a woman who might have been romantically interested in me. She thought of etching as a high-class medium, and it took awhile for her to agree to use it for beer labels. In 1979 we did that project, with the help of Fritz Maytag who owned the Anchor Steam Beer Company. He made a special brew for us in one hundred Champagne bottles with copper beer caps. Each bottle came in a box with instructions that read "This is a social work of art. To complete the artwork, the beer must be consumed, shared by at least two people."

In 1974, since Kathan didn't want to make beer labels, I came up with another idea for a print. I scored a large copper plate with an electric sander in an action/performance at the home of David and Mary Robinson, by their swimming pool. With the spinning disk of the sander, I made the shape of an ellipse, marking around the reflection of the sun in the plate. A microphone amplified the sounds. Kathan took the plate back to her shop and we printed it in sky blue ink. It was called *The Sun's Reception* and was supposed to look like the afterimage that you would see when you close your eyes after looking at the sun. I have been making etchings ever since, because Kathan

CAFE SOCIETY BEER

has made the medium available to me every two or three years.

In 1975, Kathan and I figured out a way to collaborate on a project, to combine our talents as artists: her editing and publishing abilities with my design and curating know-how. We founded *Vision*, an art journal.

We did five issues between 1975 and 1981, all of them published by Kathan's Crown Point Press. Her press is a business that prints and publishes etchings, but it also functions as a cultural institution. She produces a book about art whenever she has a good idea for one and some extra money.

The first three issues of *Vision* were in the form of a tall and narrow paperback book, shaped in the proportions of a golden rectangle. When you open

it up, it becomes almost a square. *Vision* contains works contributed by artists, who were each given two facing pages. Most of the artists sent us graphic designs, layout instructions with photos or text. But in each of the first three issues there was one original work. In the first issue, *California* (1975), Michael Asher created an invisible artwork by having his two pages glued together. In the second, "Eastern Europe" (1976), Radomir Damnjan had a page stamped with a rubber stamp that read "Free Art Work."

That issue of *Vision* was the first book in the West about the underground art in Eastern Europe, which was still Communist in 1976. A year earlier I had gone to Yugoslavia, Hungary, Czechoslovakia, and Poland, where I met artists and got photos of works from them. I started in Belgrade where I had been invited back by the Salon of the Museum of Modern Art. After that I went to Budapest and visited Gabor Attalai, and then to Prague, to visit Petr Stembera. I knew about these artists because they were in touch with my Museum of Conceptual Art, and each of them put me in touch with other interesting artists whom I invited to do pages for *Vision*. Then I went to Poland because two years earlier in Scotland I had met Wieslaw Borowski, who was director of the Foksal Gallery there, and he had invited me to have a show.

The third issue of *Vision* (also 1976) was about New York City. In the California issue I had invited two dozen artists, twelve from San Francisco (including Bruce Conner, William T. Wiley, Terry Fox, Paul Kos, Howard Fried, and Linda Montano) and twelve from Los Angeles (including Larry Bell, Robert Irwin, Bruce Nauman, Ed Ruscha, Chris Burden, and Eleanor Anton). The Eastern Europe issue had twenty-three, because that was the number of interesting artists I was able to find in the four countries I visited. For the

New York issue I only asked thirteen, and each of them did six pages. They could do whatever they wanted as long as it was related to New York. This wasn't a difficult request, because just about all New York artists' work is about New York.

I went to see Walter De Maria, who later made the famous *Lightning Field* in New Mexico. We had lunch in an Italian restaurant—I had the spinach ravioli. He said he had an idea for the book. He wanted to insert some special paper. We met later in San Francisco, where he came to visit his parents, and we went out to find the paper for the original artwork. De Maria ended up with eight pages because the insertion required four sheets folded,

EASTERN EUROPE

eight sides. On the seventh side, he had his name in gray at the bottom. There was no text or pictures. It was just eight sides of buff-colored paper. The New York issue also had pages designed by Carl Andre, Sol LeWitt, Hans Haacke, Chuck Close, Vito Acconci, and others

Sometimes Kathan would ask me to recommend artists I thought were important whom she could invite to make etchings in her shop. My recommendations were not always Conceptual artists, but usually they were. I thought of John Cage as a Conceptual artist because some of his work came out of Duchamp. However, in 1977, when Kathan invited him, he was a composer and not a practicing visual artist, although he was an important influence on artists. Like Duchamp, he had a philosophy of using chance to eliminate his own taste. In each of his works, he set up a structure that he could improvise in by asking questions and using chance to answer them. He let nature make up his mind, but he would ask the right questions. He used the same general approach to compose music, to write books, and to make art, but he adjusted it to fit each process.

Cage came to work at Crown Point Press almost every year from 1978 to 1992, the year he died. Each year, there was a development in his visual art. The first etchings were close to musical scores and by the end of the fourteen-year relationship his work had evolved into the most sophisticated art. He said that he wanted his colors to look like they had gone to graduate school.

He studied Zen philosophy in 1949 with Daisetz T. Suzuki at Columbia University, and in 1952 he presented his famous "silent" work of music

called *4'33"*. It was four minutes and thirty-three seconds in which a performer sat at a piano and the instrument was silent. On the two occasions I have seen this work performed since Cage's death, he was alive in the room. This work frames nature, and it made me aware that John Cage was there as a part of nature. What we were listening to, the ambient sounds, became music composed by him. He gets credit for all the sounds that exist in the space when the piece is performed. I saw this piece performed on television, and it was a revelation to me. All the sounds in the room where I was became a live performance of the work.

When he was working on his prints, Cage would stay two weeks at a time at our house. Sometimes when I was feeling left out of the mainstream because I was living in San Francisco, or for whatever reason, he would say something like, "You are carrying on the work of Duchamp" or "You're a great artist." With an endorsement like that, I wanted to keep working. He even bought a couple of my drawings from Margarete Roeder, who has represented me in New York for twenty years. John was so funny and kind and generous, a holy man, really, at one with nature.

He liked to cook, and would come back from working in the studio and cook dinner for our family: me, Kathan, and her son Kevin. Cage made beans and brown rice with cooked vegetables, all macrobiotic, no salads. He could make that stuff taste like gourmet food. He told us that he had been "a follower of Julia Child" before Yoko Ono had turned him on to the macrobiotic diet in order to cure his arthritis. It worked for him.

Whenever Kathan and I would go to New York we would have dinner at John's apartment. One night he told us that Louise Nevelson was coming, and it was her birthday. The first installation sculpture I ever saw was a

work of hers at the 1962 Venice Biennale, one all-gold room, one all-white, and one all-black. Nevelson was famous for wearing wild clothes and long false eyelashes, but that night she was in a simple housedress with no makeup. John asked her how old she was that day, and she said eighty. "That's wonderful," John said. "I can't wait till I'm eighty!" The sad thing is that he died three weeks short of his eightieth birthday.

1980

At the beginning of a new decade, Kathan and I produced *Vision #4*, an audio edition called *Word of Mouth*. The artists invited for this issue were asked to give twelve-minute talks. You could get twenty-four minutes on one side of an LP record, and there were three LPs in a box. So there were twelve artists, altogether, including me. The talks were given on Ponape, an island in the Pacific that Kathan and I had visited on a freighter trip that we had taken the year before from San Francisco to Hong Kong.

I hadn't gotten any grants for several years, but in 1979 I had applied to the NEA in a new category, Services to the Field, and proposed to document a conference. The grant paid to bring a sound technician and to produce the records. Crown Point Press, as publisher, paid to bring the artists. I always wanted to do an artists' conference. In 1973, I had gone to Syracuse, New York, at the invitation of David Ross who was video curator at the Everson Museum there. The museum brought everyone to that conference who was involved in video in 1973, about twenty-five people.

Our conference on Ponape was in a native-style hotel with a great outdoor bar in a jungle overlooking the sea with mountains in the distance. A couple from Los Angeles had built the hotel. The husband invented the electric carv-

PONAPE

ing knife and used the money from that to move to Ponape. It is a beautiful island, a paradise, but without sandy beaches so there were no tourists except a few scuba divers.

To get there, if you didn't go on a freighter, you had to fly in a small jet plane that went from Hawaii twice a week. We were thirty-seven people, a microcosm of the art world. Besides the twelve artists there were others who paid their own way. Several were partners of the artists. Two people owned art galleries, two were university professors, and one was a museum curator. There were some younger artists, some art collectors, and an art critic, John Perreault. He wrote up the conference in *Art in America* a month later.

We filled up the entire airplane. We had artists from Europe (Daniel Buren

and Marina Abramovic), from New York (Laurie Anderson, John Cage, Bryan Hunt, Joan Jonas, Robert Kushner, Brice Marden, and Pat Steir), and from California (Chris Burden, William T. Wiley, and me). After we were on our way, somebody said, "If this airplane crashes, the headline in tomorrow's paper will read, 'John Cage and 36 Others Perish.'"

We landed on a coral runway. The wheels were crunching over crushed coral. When we got out of the airplane, we walked to a big hut where we went through customs. The customs guy was wearing a grass skirt and an official customs hat. The luggage was carried from the airplane and handed into the building through a hole. From inside, looking out the hole, you could see the ocean.

We all got on the hotel bus, which was a flatbed truck with the hotel's wicker chairs wired down on the back. They had made up the airport bus just for us. We had booked the entire hotel. We stayed in thatched-roof cabins with no glass windows, only screens. There were waterbeds. They were cool, unheated. It rained every day in the middle of the day and that cooled things off. We went in January, the coolest time of the year, but the island was near the equator.

Every night one artist would give a talk before dinner and another artist would give one after dinner. Sometimes there was discussion, but only the talks were recorded. During the day, we made side trips. Some people in the nineteenth century thought this island was Atlantis because of its stone ruins. We had to go in little motorboats to get to them. There was a waterfall and we went swimming in a pool under it.

When the week started, we were all one big group. As time progressed, people started breaking up into camps. You take people from New York out of

New York and bring them to a tropical island and they feel some withdrawal from their fast life and start to hang out together for support. If you're from California you are more relaxed, and have an advantage because Ponape is closer to your world. In 1980, there was still a prejudice against California by New York. (In the Woody Allen movie, *Manhattan*, he says that the only advantage to living in California is that you can turn right on a red light.) Being on that island made the New Yorkers start to appreciate a California sensibility. At the end of the week, Brice Marden said, "Now I understand a little bit more what California art is all about."

Vision #5, 1982, was called *Artists' Photographs*. The first four issues of *Vision* look like exhibition catalogues, but they are not catalogues. They are exhibitions in themselves. The work was mostly designed for the books and didn't exist otherwise. But in the case of *Vision #5*, there was an actual exhibition at Crown Point Press of the original art that the artists sent in. The idea was that by reproducing everything on single sheets, printed only on one side, we could make a catalogue that somebody could use to make an exhibition.

I invited fifty-six artists from sixteen different countries to send in photographs. I asked each artist to send me a photograph not *of* an artwork but *as* an artwork. Christo sent a photo of his *Running Fence* project. It was a PR kind of photograph that he would send out to the press, and I sent it back to him and said, "I saw the *Running Fence* here in California in '76. It was a wonderful work of art. And this is a great photograph. But it is a photograph *of* an artwork, not a photograph *as* an artwork." So he sent me another photo, a picture of him with a bullhorn in his hand. He is giving orders to his crew on the project, and Jean-Claude, his wife/manager/partner, is standing next to him. It was perfect.

The works were in all different photographic media. Robert Barry sent slides that he usually projects in galleries. Joan Jonas sent a Polaroid. Michelangelo Pistoletto sent a giant negative. And Vito Acconci sent a lot of landscape photos to be hung on the wall in the shape of an airplane.

Richard Tuttle sent a small photograph, a color snapshot of a nondescript building, a one-story building with a streetlight, probably at dusk. In the upper left-hand corner is a little spot, a brown color that looks like a drop of spilled coffee. Tuttle does works that are believable but use very

CHRISTO

cheap materials: wire, cardboard, scraps that he finds and assembles. When the "Artists' Photographs" show was up, an art collector wanted to buy the Tuttle photo. I didn't know how much it was or even if it was for sale, so I called Tuttle and I said, "There is a guy here who wants to buy your picture.

Do you want to sell it?" Tuttle said, "If he can tell me what the picture is about, he can have it." I told the guy and he didn't want to guess what it was about.

None of the artists in this show were photographers. They were mostly Conceptual artists. Conceptual artists can use any medium, whatever is best for a particular idea. Painters, printmakers, and photographers define their work by the medium. A few of the artists in this show came out of painting,

YVES KLEIN

but mostly they came out of sculpture. Most Conceptual artists come from a sculpture background.

The box for this issue of *Vision* was designed to be the same size as a box of eight-by-ten photographic paper. On the cover is a picture of Marcel

Duchamp as his alter ego Rrose Sélavy. It is a famous photograph taken by Man Ray in Paris in 1921 under Duchamp's instructions. Duchamp is in drag, and in the picture there's a woman's hand. It belongs to Germaine Everling who was Picabia's mistress. The picture was retouched to emphasize the femininity of the subject.

In the text that I wrote, I used some other examples of earlier artists' photographs. One is of Yves Klein diving out the window of an upstairs apartment in Paris in 1960. It was photographed by Harry Shunk. There was actually a net and the photograph was altered in the darkroom to remove it—this was not known at the time except by a few people. The artwork shows how photographs can lie. Klein's act was not reckless. It was done to create an illusion.

Another picture in my text was by Rudolf Schwarzkogler, one of the Viennese Action artists of the 1960s who made shocking performances. It also was a photograph that most people believed showed a true event. They believed it showed the artist after he had cut off his penis. This was even reported in *Time* magazine. But it wasn't true. Schwarzkogler orchestrated photographs of models that were staged to look real.

Two earlier photographs were famous ones of Salvador Dalí and Picasso. The one of Dalí was done by Philippe Halsman in 1945 for *Life* magazine. Dalí is jumping into the air with a floating easel, a chair, three cats, and a lot of water. The chair and easel were hung from wires. Then the cats and the water were thrown into the picture at the moment that Dalí jumped. It's a work of art that can only be experienced as a photograph. The other photograph was by Gjon Mili who photographed Picasso in 1953 drawing a picture of a bull with a flashlight. It is a time exposure. Picasso was drawing in the dark while the shutter was open. The photo is another example of an artwork that,

DRAWING A LINE

because of its nature, can only be seen and experienced as a photograph. The intention behind this issue of *Vision* was to invite artists to do photographs that were intended as artworks, not as pictures of something.

1982

Living on the West Coast exposes you to a subtle Asian influence. After ten years in California, I became influenced by Zen ideas. My meditative line

drawings, like *Drawing a Line as Far as I Can Reach*, and my drumming exercises were my way to connect with Japan. By the late '70s I was anxious to go there.

Richard Newlin, a publisher from Houston who was doing a book about prints that Richard Diebenkorn made at Kathan's press, took Kathan and me to the Toppan Printing Company in Tokyo in 1980. Newlin had liked other catalogues that I designed and he hired me to design the book.

We stayed in a monastery and ate fish and pickles and seaweed for breakfast. Kathan got the idea to try to do woodblock printing in Japan. She got in touch with a man named Tadashi Toda in Kyoto. He was an expert woodblock printer in the classic Japanese tradition.

I got a grant in 1982 from the Asian Cultural Council in New York to travel in Japan so I did a project there, some erotic silkscreen prints and ceramic sake cups in small editions. You could drink sake and look at the dirty pictures at the same time.

That same year, Kathan began to invite artists to go to Japan to make woodblock prints. The artist would make a watercolor. Then the watercolor was sent to Japan where the printer would trace it and have the blocks cut. When all that was done, Kathan would take the artist over there. Toda would already have made a proof. The artist might say, "This is wrong," or "This is too heavy, too dark, too light," or "Make a new block for this." That could all be done while the artist was there for a two-week stay. If I liked the artist, I would sometimes go along on those trips.

The Japanese woodblocks are rectangular, with several different ones for each color. Each print has a lot of blocks, usually twenty or more, and Toda registered them by just laying the paper down and lining up a little

cut in it with a mark at the corner of the block. The ink is made of water and pigment. If the artist wanted a really bright red, Toda would have to ink the block and print it, and then ink it again and print it. He would do this several times to build up the color. The ink was watery, not tacky and thick.

Later in the '80s, the value of the yen went up against the dollar and it became so expensive to do the prints in Japan that finally it was impossible. So Kathan went to China. In China, I made several prints. One was called *Flying Yen*. The symbol for the yen is a *Y* with two lines across it. My print looks like a bird flying. I drew the strokes with a feather, which is a writing and drawing instrument rather than a painting instrument. When the yen was falling a few years later, I thought you could turn my print sideways and change the title to *Falling Yen*.

Kathan and I made our first trip to China in '87. A China scholar, Soren Edgren, went with us to Beijing. His future wife, Xia Wei, was teaching at the university there. Through them, we met Professor Yong Hua Yang, who had been a Russian teacher when the Russians were friends with China, but was at that time an English professor at Hangzhou University. He ended up being the translator and the manager of the Crown Point China project.

In Beijing, we went to Rong Bao Zhai, a woodblock print shop that was hundreds of years old. I was the guinea pig. I bought a piece of silk from the print shop store, and a big brush, and some ink. Back in the hotel I wet the silk and stuck it to the window glass, then made my ink mark on it, a single long brush stroke. The next day we took the drawing to the shop. The boss told me they couldn't carve the fine lines that the hairs of the brush had made. There was a print on the wall with fine lines in it and I said, "What about this?" He said, "Those aren't lines. Those are dots." We looked at it

PEKING

with a magnifying glass and sure enough, the lines were dots. If you cut wood so thin that it's only as thick as a piece of hair, it wouldn't be strong enough to stand up in the printing. So instead, they cut the detail lines into little dots. They agreed to do mine that way. I asked how they got the background color in an old print hanging on the wall, and they told me it was stained with tea. I said, "Okay, I want mine like that."

The system for making woodblock prints in China is very different from

in Japan. What they do in Japan is trace the gradations in a watercolor painting. The tones go from dark to light, so they make maybe two or three separate blocks to show the darkest part, more blocks to show the medium part, and even more to show the lightest tone in an area. Each change in tone is carved into a block. When you look at a print up close, you can see the gradations are carved in steps. There are hard edges. Even though from a distance the print looks like a watercolor painting, the printer has "Japanized" it, as Francesco Clemente said. It has ended up with a Japanese look, very clean and precise.

When the Chinese want to show a gradation, instead of cutting a block for each darker or lighter tone, they imitate the brush strokes while they are inking the block. In a picture of a bird in a tree, for example, the bird is darker on the bottom where it's in shadow. First, they cut out a piece of wood in the shape of the bird; the block is just the bird shape. Then they fasten that block to the table with a piece of wax. In order to get shading in a solid piece of wood, the printer takes a brush and paints the tone, actually imitates the painting, right on the block. Paint the bird and then print the painted bird on the paper.

The size and shape of each block is determined by the image on it, so the registration system does not involve the blocks. All the paper is in a stack fixed to the table, like a telephone book of blank pages. There is a slot in the table next to the paper. After painting the ink on a block, the printer folds a sheet of paper over it, rubs the back, and then pushes the paper down through the slot in the table. Then the printer inks the block again, and takes the next piece of paper and prints it, like turning pages in a book. Print a sheet, and push it down through the slot, then do it again and

again until the bird is printed on all the pieces of paper. Then the printer takes away the bird block and puts another block down—maybe that would be the tree branch the bird is standing on. Next, the printer takes all the

BIRD

pieces of paper that are hanging under the table, and pulls them up through the slot to the top of the table, folding them back to their original position. Then she starts all over. (Printers are usually women, and carvers are men.)

In China, they print on very thin paper or on silk, and this is mounted on a scroll or some heavier paper. In Japan, they print on thicker paper that we call rice paper, but it's not made from rice; it's actually made from bamboo or other plants. People in the West think paper is made from rice because it looks like rice and rice is so important there. Most beers are made from rice in Japan.

When the Chinese printers mounted the prints they did for Crown Point, sometimes they would get little bits of hairs and dirt caught in the glue. Because the paper or silk is so thin, you could see the dirt grains between it

and the backing sheet. Kathan would send the prints back and tell them there's dirt in them. And the manager would tell her she wasn't supposed to see that. "Nobody sees that," he said. The idea was that it didn't matter about the mounting. You weren't supposed to see the dirt. You were just supposed to look at the image, and they did a great job of printing that.

The Chinese printers had their own ideas about what the image should be. When we took them Robert Bechtle's drawing of an automobile in front of a house, done from a photograph, they said, "Why would you want to make a print of this?" They didn't understand why they should bother making all the blocks and doing all the work needed to make Bob Bechtle's print.

Bechtle's first proof came out well, but they had to completely redo the edition. They had beefed up the colors, made them too bright, and when Bob looked at the prints, he said, "This is terrible." They had sent the whole edition, fifty prints. Crown Point sent them all back to China, and they were surprised. They said, "We improved the print. We made it better. The colors were too dull." They had to do it over.

We learned about the cultures by doing business in China and Japan. Japan is a very refined version of China. China's the old culture, five thousand years old, and Japan is relatively new. Everything in old China is dark. Even the furniture is black-lacquered and heavy and dark. The culture in Japan came out of Chinese culture, but it is much lighter and more elegant.

In Japan, only a few hundred years ago, the first writing was done by women. The men were mainly warriors, samurai soldiers, and the women were involved with the arts, especially writing. Much of Japanese culture is like a female version of China, more refined and smaller in scale. Japanese people can read Chinese. The written character for *tree* is the

same in Chinese as it is in Japanese. But modern words in Japan are written according to the sound of their syllables.

My name, Marioni, is four syllables, so in Japanese it would be four characters: a character for the sound *Ma*, and *ri*, *o*, and then *ni*. In China, they don't do it that way. You wouldn't sound out a name. My Chinese name is Ma Tang. It means "fast running horse." A Chinese person gave me that name because she thought that I look like a fast running horse, and the words have some similarity to the sound of my name. And then the name is reversed. Marioni is first, and Tom second: Ma Tang. Marioni Tom.

After my first trip to China, when I learned that the language is written in a way that explains the meaning of the words, I became interested in learning to write Chinese. The way to write *music* is with two characters: *sound* and *harmony*. *Museum* is written with three characters: *many*, *things*, and *place*. And the way to write *art* is with *beauty* and *skill*. I had fun writing that word because the character for beauty looks to me like a woman dancing, turning around so that her dress twirls with her, while to her right is the character for skill, a man standing straight and turning his dancing partner.

When I write Chinese, I use the soft end of a seagull feather dipped in ink. The feather holds less ink than a brush. You have to dip it for every stroke, and before the stroke is finished it begins to show gaps. Sometimes the mark takes on the look of a feather. And sometimes the feather skips across the paper and leaves a winglike mark. There is a great name for that kind of dry look in brush calligraphy. It's "flying white."

After the massacre of students in Tiananmen Square in China in 1989, I made an installation piece, a tableau sculpture called *Beijing*. An old bicycle, painted black, sat in front of one of my shadow drawings on a

ART

large sheet of yellow paper. It is the suggestion of a figure, but the figure
has been taken away. Only the shadow is left. Between the bicycle handle-
bars I fixed a large traditional Chinese calligraphy brush that I had
shaped in the form of a torch with a windblown flame. On the back of the
bicycle a flat piece of black wood stuck out like the flatbed of a small
truck. In China, almost everything travels on bicycles. There can even be
a restaurant on a bicycle, with a little stove on a platform on the back, lit-
tle dishes that pack inside it, and stools that fit underneath. People sit
around the bicycle on the street and have food. Sticking up from the plat-
form on my bicycle was a rod, at an angle, with a white dinner plate bal-
anced (actually glued) on top of it. This referred to the acrobats we saw in
circuses in China, who always twirl plates on the ends of sticks. Also on
the platform was a small cricket cage with two brass balls inside it, the

kind of balls that people roll around in their hands to keep their fingers limber. Nixon once said, "If you have them by the balls, their hearts and minds are sure to follow."

During the '80s most of my work was concerned with places and cultures. In 1982, an artist friend in Japan, Yasu Suzuka, offered to organize a performance for me in Kyoto. I said I'd like to do it in a Shinto shrine. Because he was friends with a Shinto monk, he was able to arrange for me to use a small building in the Ohara Shrine, just outside

BEIJING

Kyoto. I called the performance *Studio Kyoto.*

The Ohara Shrine is on the side of a hill, among trees, and the performance was at dusk, beginning at 5:30. People arrived while it was still light and stood outside in front of the building. Inside was a woman playing a koto, a stringed instrument that lies horizontally on the floor. In order to play it, you have to bend your body to reach the strings. I had stretched a piece of tracing paper to cover the door opening, so only the woman's shadow would be visible. When people came, they could hear the koto but could not see the shadow because it was still light outside, just starting to get dark. Inside the shrine, behind the woman, I had placed a candle with a little mirror that projected the candlelight onto the paper that covered the door in front of her. As the light outside faded, her shadow slowly appeared and got stronger and stronger.

I stood outside, in front of the doorway, and as it got darker I became a silhouette against the paper. Behind the paper, right up against it, was a microphone. I drew the woman's shadow, and my back and forth motion made a percussive, scratching sound. I provided a kind of Western rhythm for her Eastern music. I used a pencil on a long stick that looked like a conductor's baton. She was inside and I was outside. The performance went from light to dark. It was male/female. The thin membrane of paper separated us.

She wasn't fixed in one position. Her body moved gracefully, and I had to follow her body with my body in order to draw her shadow. There was a marriage of shadows. My pencil was caressing the paper, and her music on the other side of the paper was responding. Because she was moving, the drawing didn't end up looking like a particular form. It was almost

like a drawing of smoke. I thought of it as a drawing of a spirit.

The three elements of male, female, and spirit have dominated many of my installations, especially those that deal with cultures. In 1981, in San Francisco at the alternative art space called SITE, Inc., I did a show called "The Past" that presented installations symbolic of three cities on three continents: Kyoto (Asia), San Francisco (America), and Paris (Europe). Part of my approach was to think of Kyoto as spirit, San Francisco as male, and Paris as female.

There were three skylights that I covered with colored gels: yellow, blue, and red. I had made three large lithographs, one for each of the cities. They were like travel posters, with the names of the cities printed in

STUDIO KYOTO

gold, each in a different typeface. There were no images, just a mono-chrome rectangle in a different color for each city. All three lithographs were printed from a single stone with rounded corners, and the colors were printed from the whole surface of the stone.

Under the yellow skylight was the work called *Kyoto*. The lithograph in that installation was the color of straw, and underneath it I raised the floor to define the space and covered it with straw mats like tatami mats. Mounted in the wall behind the mats was a miniature television set tuned to a TV channel but without sound. Sitting in the middle of the floor was a plaster flattened sphere that I had made, a copy of the flying saucer in the 1951 movie *The Day the Earth Stood Still.* It looked like it was hovering over the straw mats, and to me it represented the perfectly placed rock in a Japanese garden.

Under the blue skylight, in the center of the room, was the installation called *San Francisco*. The blue light represented the fog, the cool light of the sky. The lithograph was blue-gray. Under it was a pedestal and on top of that a spittoon, a reference to the Gold Rush. Like a halo behind the spit-toon was a drum cymbal, a circle of yellow brass—San Francisco was a jazz town in the past. Hanging down from the ceiling was an electric sign that said "Private Investigation"—all those Sam Spade and Dashiell Hammett movies took place here. A painted black railing, which had an Asian look, was in front of everything.

The *Paris* installation was under the red skylight, and the lithograph was printed in burgundy, like red wine. This part of the room was filled with pink light, kind of sexy. There was a traditional artist's travel easel like Monet might have used. On the easel in place of a canvas was a piece of

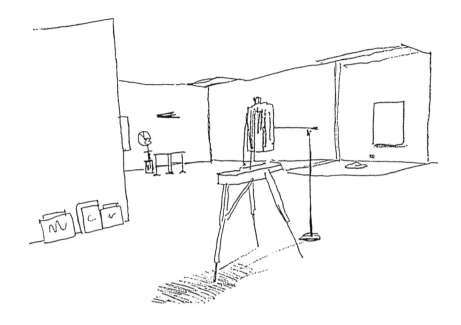

PARIS SAN FRANCISCO KYOTO

copper, like a mirror. A drummer's wooden drumstick pointed toward the copper, almost touching its reflection. I thought of Brancusi's *The Kiss*. The position of the drumstick suggested the juxtaposition of music and art, and it was held in place by a boom microphone stand.

I had made seven drawings that were copies of works of famous twentieth century artists: Picasso, Matisse, Magritte, and so on. They were framed and leaning against the wall, like drawings you might see in the back room of a French art gallery. On the floor was a wine bottle painted blue, with a corkscrew that looked like a bird perched on top, looking at itself in a gilded French mirror. In the corner was a narrow door with a window in it. This

referred to Duchamp's famous door that came from the saying, "A door must be either open or closed."

Duchamp had his famous door made in 1927 for his Paris studio at 11, rue Larrie. The door was in a corner, and in one position it was closed onto the bedroom and open into the next room, and in the other the bedroom was open but the next room was closed. After Duchamp moved to New York, he paid somebody to take the door out of the Paris apartment and ship it to him. He signed it, and later it was bought by an Italian art

THE LARGE GLASS

dealer who loaned it to be exhibited in one of the Venice Biennales. One night the crew was cleaning up, touching up, puttying holes, and painting the walls white. Not realizing Duchamp's door was art, they painted right over his signature.

Duchamp's most famous work, *The Bride Stripped Bare by her Bachelors Even*, or the *Large Glass* as its often called, was the inspiration for an installation I did in 1985 in Los Angeles at the Otis Art Institute for the New Music America Festival. My piece was titled *The Marriage of Art and Music for L.A.* In Duchamp's *Large Glass* he symbolizes a marriage of male and female elements, with the male in the bottom panel of the glass and the female in the top. In my installation, the male is on the right and the female on the left, side by side like a couple at the altar. The female, represented by a piece of copper cut in the shape of a violin, is on an artist's folding easel with two Mexican maracas hanging down between its legs, suggesting a horse. The male is a telescope on a tripod, with two LP records attached to it. Its shadow looks like a movie camera, with the records as film reels.

A large theatrical spotlight created the movie-camera shadow, and another spotlight was focused on the copper to project a violin-shaped light reflection next to it. The marriage that was taking place was between shadow and light.

There were other objects that made reference to music and art, and behind everything were yellow fluorescent lights, bleeding out to the sides of the work, making a kind of glow. In front was a railing that suggested

both a church altar and a Hollywood sound stage, emphasizing the the-atricality, and keeping people at the proper distance.

A small sculpture I made on a pedestal at about the same time also relates to the idea of art and music joined together. A wooden hand is hold-ing a bamboo flute that is pointed at a small framed drawing of a spiral. The picture is supported by a chunk of white marble

As far as I'm concerned, not much happened in the '80s. That was a low period in art for me. The art market thought the '70s would never end, but

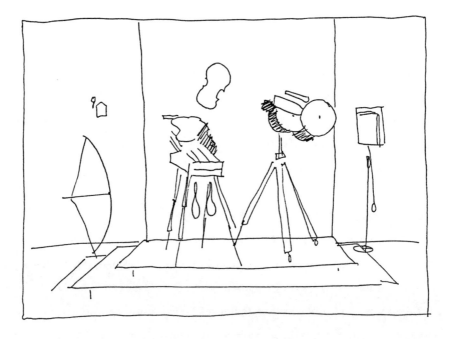

THE MARRIAGE OF ART AND MUSIC FOR L.A.

of course they did. Painting returned, and art was all about money and fashion. The whole point of Conceptual Art in the '60s and '70s was to break away from all that formalist stuff—many artists in my generation

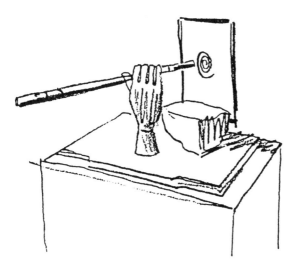

BIRD IN HAND

really thought painting was dead. Even Warhol declared it dead in 1968. I thought it was an old, quaint, pictorial form that had evolved over five hundred years into an aesthetic that was about flatness and paint. I thought it had run its course.

Duchamp said in the '60s that the public was admiring his readymades for their beauty, even though when he had selected them as readymades fifty years earlier, he was throwing the whole idea of aesthetics in their faces.

In 1980, Lucio Amelio, an art dealer in Naples who had one of the most avant-garde galleries in Italy, organized a show with Joseph Beuys and

Andy Warhol. At the time, Beuys was the champion of European art. He was the most famous contemporary artist in Europe. And Andy Warhol was the most famous artist in America. Beuys made an installation of his sculptures, and Warhol hung a series of portraits of Beuys. They were silkscreens printed in negative on canvas with diamond dust, so they had a glitter effect like stars in the sky. Beuys's work was not about Warhol, but Warhol appropriated Beuys as he did with everything and made him his subject.

They both went to Naples for the opening of the show. It was a big media event in Italy; this was the heavyweight championship of the art world. Warhol was the winner. He had a clever strategy, but I was pulling for Beuys. Warhol's art is about plastic materials, fashion, and celebrity. Beuys's art is about natural materials, morality, and politics.

Warhol was on Italian TV. He was interviewed for the news. They asked him, "Are there any interesting artists in Italy?" "No," he said, "there aren't any artists in Italy, except maybe Giorgio Armani." It was very funny, but of course the Italian artists were insulted.

In 1979, at the end of the Conceptual Art era, I wrote a manifesto and concluded it this way: "Now the break from the object isn't an issue any more. Ten years ago, it was important to make a statement against materialism, by making actions instead of objects. Now, with some artists in my generation, there's a return to the object, not as an end in itself, but as material to explain a function, like before the Renaissance, where the object was used in a social, architectural, or religious way. But the late '70s are, and the '80s probably will be, a cosmetic age of decoration and theatricality."

<p style="text-align:center">***</p>

In 1979 I did a performance called *A Social Action* in the Dany Keller Gallery in Munich, Germany. The gallery director wasn't prepared for a performance as an installation designed for the space. I wasn't prepared to be up there tap dancing on a platform in a room full of somebody else's paintings. She said, "I can't take the paintings down. There isn't time, and I don't have any place to put them."

So I said, "Isn't there a room somewhere where there are no paintings hanging ?" Right off the gallery was a door that led into the toilet. It was the only room with nothing else in it.

I took the door off and set up my drawing board over the toilet. It was one of those toilets that flush as long as you hold the handle down, and I taped the handle so the water was constantly running, making a rushing sound, like a waterfall. I sat on a chair facing the toilet and made a drumbrush drawing, drumming on sandpaper on my drawing board, and I was thinking Water Music.

People arrived. They walked around. There was a table with free beer— that was part of the deal. They saw my back and heard the sound; they drank their beer, talked, and socialized in the gallery. It was like Noh theater in Japan: while people watch the play, they talk to their friends, sleep through part of it, go out, come back in, have tea. They go for the social experience.

Later a German curator, Kasper Koenig, said to me, "At first I was really put off. I thought, 'What is this guy doing in there? Why isn't he out here performing to us?'" Then he said, "Finally I realized it was honest labor that you were doing." But he knew that most of my work at that time was about different cultures, and he said, "So you came to Germany and you did a piece on the toilet. Is that about Germany?"

I had just come from Bologna, Italy, where I had done a piece in the Pellegrino Gallery, which was in a beautiful old building. I had three empty rooms to work with, four-hundred-year-old rooms, with stone floors and whitewashed stone walls. I bought a slab of the softest marble I could find and set it up on a small drafting table. Then I projected a yellow light past the door of the first room through the second room and into the room where I worked at the table.

The light illuminated my action with a rectangle of yellow, like a golden rectangle. I drummed with a pair of gold-plated drum brushes on the marble for an hour and a half, and the drum brushes polished the marble in the pattern they normally make when I draw with them, a birdlike pattern. Where the marble was polished, it became smoother and reflected more light. At the end of the performance, people came up and touched the stone with their hands. There was nothing to see. This work was about sound and touch.

The title of the performance was *Liberating Light and Sound*. I got that title from something Marina Abramovic said to me after a performance I did in Yugoslavia five years earlier in 1974. That performance was titled *A Sculpture in 2/3 Time* and in it I polished a spot in a large rusted piece of steel, first with an electric sander and then with emery paper and metal polish. After that I dragged a drumstick across the metal, back and forth, and as it went from a rusty part to the polished part to a rusty part—from rough to smooth to rough—what you heard was one, two, three, like a waltz, and what you saw was one, two, like a pendulum moving. Marina Abramovic said, "Oh, you liberated light and sound from the material, from the steel," and I thought I would use that title at another time.

During the '80s I did a series of staged performances called *Studio* which were accompanied by recorded music. They were a combination of several things I had done up to that point, including drawing in front of an audience, using shadows, and amplifying the sound of my mark making, but they were also influenced by two artists who had lived in Paris.

In 1962 I visited the Museum of Modern Art in Paris and saw Constantin Brancusi's studio installed there. When he died in 1957 Brancusi left the contents of his studio to the museum, which re-created in three rooms his sleeping, eating, and living quarters, filled with many un-finished sculptures. This idea of the studio as installation combined in my mind with a performance work done in Paris in 1960 by Yves Klein, who died at the age of thirty-four in 1962. Klein's performance was called *Anthropometry* or *Living Brush*. He painted the bodies of nude models with blue paint and had them press against large pieces of paper, while a string orchestra played his *Monotone Symphony*. This was a demonstration of the act of art in front of an audience.

My *Studio* performances were similar to one another but with subtle changes depending on the country where I did them. The music functioned as background—I set up the mood of an artist's studio, with recorded music as an element that in some parts of the performance accompanied the rhythmic sounds of my drawing. I would fill in my shadow on a piece of paper with a long pencil, and—because of the way I set up lights and a small curtain—when I would back away from it my real shadow would disappear into the drawing. Afterward, I would light a cigar, and the smoke would create its own shadow and a smell like incense.

When I was in Germany someone said to me, "Your performance was

like romantic German painting from the nineteenth century." That was because of the dramatic shadows. When I did basically the same performance in Paris, somebody said, "You have a French sensibility." Before that performance in Paris, at the Pompidou Center, a woman asked, "Is your performance going to be in French?" That took me by surprise, because I think the basic difference between theater and Performance Art is that in theater you tell a story, generally using words, while in Performance Art you use another language, a visual language. It is a visual medium like sculpture.

BRANCUSI STUDIO

Earthquake, 1989

On October 17 at 5:04 p. m., a 7.0 earthquake hit San Francisco for fifteen seconds. People were just getting out of work. I ran to the front door of my studio, which was right on the street, and stood in the doorway holding on to the side moldings and riding it like a bucking bronco. The trolley buses stopped because they lost their power, and people poured out of buildings. But everything looked oddly calm.

The city was dark that night, and for the next twenty-four hours there was no power. Later people would talk about where they were when they heard that the Bay Bridge collapsed. I was walking, looking for Kathan, and she was looking for me. Someone in a car who was listening to the radio shouted out to the people on the street: "The bridge is down!"

For a month, Kathan and I took a ferry to work from Berkeley until the Bay Bridge was fixed. The day after the earthquake, my building was condemned and padlocked by the city. For the next few days, they let tenants in a few at a time for just an hour at a time to move out belongings. I dragged my furniture and art down the stairs to the street and stacked them on the sidewalk. My artworks were mostly parts of installations: a spittoon, a bicycle/truck, a telescope on a tripod, things like that. The city's redevelopment agency, my landlord, moved all my stuff to an art storage facility with climate control until I had my new studio.

In the meantime, I had my Café Wednesday down the street in another bar, and I began working on a show titled "The Artist's Studio: Starting Over." This was an ongoing installation at the Capp Street Project during the first three months of 1990. Two prominent mainstream alternative art spaces, Artists' Space and the Capp Street Project, had opened in the '80s.

BAY BRIDGE

(The alternative art scene as an underground movement had been over in San Francisco by 1980.) Both these mainstream spaces were started by wealthy women who (like Peggy Guggenheim in New York in the 1940s) love artists and are romantics about the art world. Artists' Space was the more short-lived of the two. Anne McDonald started it as a Conceptual Art exhibition space. Ann Hatch founded the Capp Street Project, which was a gallery for Installation Art where artists were in residence for three months at a time. I made works in both places, and I respect both of "the two Ann(e)'s" as I used to refer to them, for taking the initiative in supporting new art.

I used the opportunity at the Capp Street Project to combine a studio with a bar for my Wednesday parties and to design the construction of my next studio. In thinking about starting over, I remade several old works from the '70s, including a drum brush drawing. My drum brush drawings were devel-

oped as a demonstration of a solitary activity, a metaphor for an artist's work in the studio, a kind of automatic writing that is drawing. When I did them in performance, half the art was somewhere in the air, a white noise that might make a psychic connection between the audience and me.

I also made a line drawing based on *Drawing a Line as Far as I can Reach*, which I did in 1972, and I remade *Running and Jumping with a Pencil, Marking the Paper While Trying to Fly*, also from 1972. The new version was called *Flying with Friends*. I was fifty-two in 1990 and could not make the athletic drawings I had done when I was thirty-five, so I asked my friends to help me. But, what the heck—Sol LeWitt had been having other people make his drawings for years. The main difference was that LeWitt's drawings were Constructivist and my flying drawing was Expressionist.

The two Ann(e)'s started their art spaces using their own money, but eventually the Capp Street Project began to apply for grants and do other things to raise money. They would hold fund-raising auctions. Although those two spaces no longer exist, there are other good causes, and I am asked (along with most of the other artists in San Francisco) to donate work to support their programs.

I used to call in my work on the phone. I would tell the organizer to type a card that read "private performance" or "work to be determined later." For several years, each time I did that the good cause would sell my work to Austin Conkey, who has bought other works of mine from time to time. Finally, I called in a donated work and had them type a card that read "for Austin." Of course, he bought it.

These days, I send in a card that reads "cocktails for six in my studio." I get half the money paid for my work and use it to buy the cocktails, and six

nice people come to my studio and we have a party. I already have a bar, because of my Wednesday artists' club. For years, I have been making installations called *The Artist's Studio* and performances called *Studio*, so this as an extension. My studio became an art installation some time ago. It's one way to make art that has a use.

I've been in the same neighborhood since 1965. Now, the San Francisco

**RUNNING AND JUMPING WITH A PENCIL,
MARKING THE PAPER WHILE TRYING TO FLY**

Museum of Modern Art is around the corner, and it has become an art neighborhood. In the Crown Point Press building where my studio is, the press has a gallery and bookstore/reading room as well as its studio for making etchings. There is an entire art system in the building. Another gallery and an art consultant's office are in the basement, and upstairs is a little store for artist-made books. Hawthorne Lane, which is on the ground floor, is a great restaurant with real art hanging in it. I ride my bicycle six blocks from home every day. It's a good life.

<p style="text-align:center">***</p>

The Museum of Modern Art's new building on Third Street opened in 1995 on the spot where my studio was back in 1969. The redevelopment agency tore down the whole block in 1975, and twenty years later the museum was put there. In 1987, the museum had hired Jack Lane as director, and he oversaw the fund-raising and construction. He had been director of the Carnegie Institute in Pittsburgh. He is the nicest museum director I have ever met: polite, soft-spoken, and respectful of artists. When Henry Hopkins was director, he hadn't wanted to know what was happening in the '70s. He wrote a book called *West Coast Art* that did not include Conceptual Art or art from the rest of the coast north of California.

In the case of Jack Lane, he came into contemporary art late. He just didn't know about that period in general, and neither did his chief curator, John Caldwell. They were part of the East Coast establishment, so they didn't imagine there could be anything important here. By the time Lane came in, painting had returned to the art world. The Germans were big,

and the museum bought lots of German painting. Whatever was hot at the moment in a few New York galleries was what the museum showed. It became like an East Coast museum that was transplanted here. They took their orders from central headquarters. Jack Lane was director for ten years.

After Lane left in 1997, the trustees hired David Ross, the most controversial director in the country, and he resigned under extreme pressure after only three years. Ross had been director of the Whitney Museum before he came here. He is a media man. He started out as video curator of the Everson Museum in Syracuse, New York, and then went to Long Beach to be a curator of video and film. In every one of his jobs he has championed media and technology.

SF MOMA

He was chief curator of the University Art Museum at Berkeley in the late '70's, and at that time had been a supporter of the Conceptual Art scene here. As director of the San Francisco Museum of Modern Art, he was beginning to show signs of support for local artists. A lot of his energy went toward buying important works for the collection—he (with curator Gary Garrells) gave the Bay Area credibility by getting two important works: the Rauschenberg *Erased de Kooning* and a study for Duchamp's *Large Glass*, both paid for by our great philanthropist, Phyllis Wattis. In the '60s this museum was provincial and mostly collected work from Bay Area artists. In the '80s it was the opposite of provincial and mostly collected art from New York and Germany. In the '90s, some Minimal and Pop Art was donated to it. But there are still big holes in the collection. There is very little first-generation Conceptual Art, and not much European art except German painting.

In recent years the San Francisco Museum of Modern Art has begun to acquire some of my work. They have a two-part tableau sculpture from 1986 that includes elements that are symbolic of the opposite cultures of Germany and Italy. The two installations sit side by side and each contains a framed lithograph surrounded by objects. The lithograph in *The Germans* is gray, black, and blue and has in it a diagram of an eyeball to show how a lens works. The lithograph in *The Italians* is in warm colors, mainly yellow, and contains a diagram of the inner ear and a design by Leonardo for an Italian basilica. Each installation contains a table that holds objects. The German table is wide and low, and the Italian is tall and thin. On the German table are a plaster Baroque sculpture detail, two beer bottles, and

THE GERMANS AND THE ITALIANS

an iron bread tin. On the Italian table are wine and oil cruets, a gold-plated pizza cutter, and a wooden knife for cutting pasta. Next to the German lithograph, on the wall, is a metal eraser shield of the type that architects use to erase something very precisely. Leaning against the wall in the Italian installation are a pizza board, a drawing board, and a piece of copper.

The German materials are scientific and intellectual; the Italian materials are operatic, artistic, and sensual. Iron is black and hard. Copper is golden and soft. *The Germans* is illuminated with white light, *The Italians* with yellow light. These two installations, and the two cultures they symbolize, represent male and female to me.

A year after I made this piece, I showed it in the Museo ItaloAmericano in San Francisco and added a third component to represent spirit: *The*

Japanese. That installation has at its center a long scroll on which is mounted a blank piece of paper. On either side of the scroll are two of my ink drawings done with a feather; one is a single vertical stroke, the other a circle. Under the scroll is an empty box open at the front. On top of that is another box containing sheets of blank paper with gilded edges. On top of that is another empty box tied up with a black ribbon. Leaning against the wall is a sword sheathed in a wooden case.

Another work of mine owned by the museum also has elements of male, female, and spirit. *Free Beer (The Act of Drinking Beer with Friends is the Highest Form of Art), 1970-1979,* is an installation that contains my old 1950 Coldspot refrigerator from MOCA with the words *Free Beer* printed on the door and behind it on the wall a shelf unit with 216 empty bottles of Anchor Steam Beer. A yellow lightbulb hangs from the ceiling and illuminates the bottles and the refrigerator. The lightbulb represents the spirit (enlightenment), the refrigerator the female (container, nourishment, womb), and the empty beer bottles the male (phallus).

<p style="text-align:center">***</p>

During the '80s my main interest in sculpture was in making installations, and this extended to small installations inside deep, framed wooden boxes that hang on the wall. In the nineteenth century these were called "shadow boxes," and that's what I called mine. I spent more than a year in 1988-89 making a series of seven boxes based on the Creation as described in the Bible: Sunday, the universe. Monday, the moon. Tuesday, trees and water. Wednesday, fishes. Thursday, birds and mammals. Friday, Adam and Eve. And on Saturday God rested.

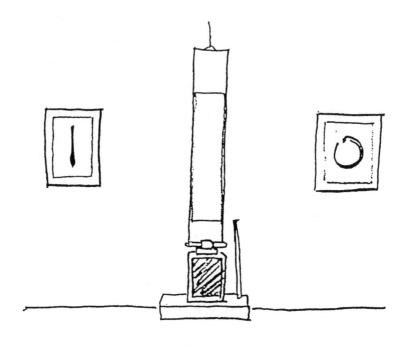

THE JAPANESE

The boxes are birchwood, and each one is named for a day of the week and is filled with objects, some mounted on the birch background, some resting on the bottom part of the frame. Each box also makes reference to an artist who has influenced me.

For example, the box titled *Sunday* reflects the creation of the universe, and the artist is Leonardo da Vinci, the godfather of Conceptual Art. In the box is a printed copy of a drawing by Leonardo of a male and a female copulating, in profile, as an anatomy drawing, accompanied by gears, pulleys, and mechanical devices. I think this drawing by Leonardo was an inspiration for Duchamp's *Large Glass*. Above the drawing is a small black book

with a red firecracker attached to its cover, the fuse sticking straight out toward the viewer. Above that are holes drilled in the pattern of the Big Dipper, each with a burn mark in it, trailing to the left. Also in the box are a tuning fork, a cocktail glass with liquid (it is a trick glass), a quartz crystal, a gold saucer used by priests for Communion, and another Leonardo reproduction, of a church, this one drawn by me. At the top center of the box is a (shooting) star-shaped piece of copper with a spherical compass mounted under one of its points.

The artist-subjects of the other six boxes are as follows: Monday, Marcel Duchamp. Tuesday, John Cage. Wednesday, Joseph Beuys. Thursday, Constantin Brancusi. Friday, Yves Klein. Saturday, Pablo Picasso. Duchamp was the inventor of Conceptual Art as Cage was the inventor of Happenings

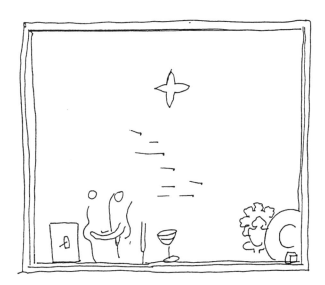

SUNDAY

as Beuys was the inventor of the sculpture action as Brancusi was the inventor of abstract sculpture. Klein was the inventor of elemental art using air, earth, fire, and water, and Picasso was the inventor of Cubism. Of course, da Vinci invented almost everything.

Sometimes people say to me, "How can I know what your work is about if you don't explain it?" I usually answer that I go for a mood, and the things I use have meaning to me and are suggestions of the mood. If the mood is all the viewer responds to, that's fine. But if you want to, you can look for clues, like figuring out a mystery. The curator in me likes to talk about what my objects mean to me, but I realize that the mystery can be taken away if things are overexplained.

At parties, people often ask artists, "What are you working on?" Sometimes I say, "Psychic sculpture." They ask, "What is that?" And I say, "It will come to you."

<p style="text-align:center">***</p>

Galileo's index finger from his right hand is enclosed in a gilded glass egg on top of an inscribed marble pedestal at the Institute and Museum of the History of Science in Florence, Italy. I saw that finger in the late '70s and thought it looked like a religious relic from a saint. It was black and shriveled, like a mummy's finger; it was the actual finger, the one that focused a telescope at the planets for the first time.

In 1988 at Margarete Roeder's gallery in New York I made a whole-room installation sculpture that was built around half a plaster mold of my index finger, pointing upward. It supported a lens that reflected light onto a small silk flag blowing in the wind from a hidden fan. The difference between Galileo's real finger in the glass egg and my finger in the installation is that

the one I made is in negative profile. It is the mold rather than the cast that would be made from the mold. It is a stand-in for the real thing. Because of that it can be art. Real life is not art. The finger-relic is not art.

Galileo made beautiful small watercolor studies of his observations of the moon as he saw it through his telescope. Today, an astronomer would take photographs. These watercolors were records, not made as ends in themselves. They look like art, but they are not art. If a curator put them in an art context, they still would not be art, because a curator can't make something into art (although today many curators try). I could pay homage to Galileo by copying his drawings, photographically or otherwise. If I did that, I would be changing their meaning, and they would become my art.

That could be an example of appropriation art. In the early '80s I made several works that appropriated famous artists' works. The largest of these

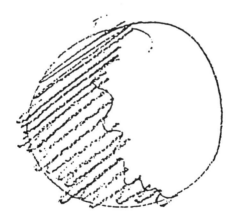

GALILEO'S MOON

was the central work of an exhibition called "Art Against War" in the gallery of the San Francisco Art Institute. I was teaching a class there in gallery studies, and the exhibition was organized as a class project. We made a copy of Picasso's famous painting, *Guernica*, which Picasso painted in black, white, and gray as an anti-war statement in 1937. We worked from a photograph that I had divided into grids, and each student painted one square on a canvas that was attached to the gallery wall. The painting is very large, twelve by twenty-six feet, and we made a facsimile copy (samesize, as opposed to a reproduction, which could be any size). A reviewer for a small local newspaper, not realizing that Picasso didn't use color, reported that the copy was a black-and-white version.

In the "Art Against War" exhibition the scaffolding we used remained in front of the painting, and the students continued to work on it during the show. Later, I used the painting several times as a backdrop for other sculpture installations.

1990

In 1990 I made a small work that used a fragment, a splinter, from another artist's work. This wasn't appropriation. It was theft. I framed the splinter. It was different from Galileo's finger, because that relic wasn't intended as a work of art. My splinter-relic was.

The splinter is from the old Spanish door in Marcel Duchamp's *Étant Donnés*, his installation in the Philadelphia Museum of Art. The splinter will not be missed. It is tiny and the door is very ragged. *Étant Donnés* was Duchamp's last work, dated 1946-66. The door is framed by a brick archway, and has two small peepholes. You don't notice them until you walk up

close. Just below them is a crack made smooth by thousands of noses hav-
ing been pressed there as people peered through the peepholes. Doing this,
you see a foreshortened room and, a few feet inside, a brick wall with an
irregular hole in it big enough to crawl through. Behind that hole you see
part of a naked female figure. One arm is holding up an illuminated
lantern; the head is outside your view. The feet are also outside the brick
frame. A classical landscape is in the background. The figure is lying on a
bed of twigs with her legs spread wide revealing all. As I looked through the
peepholes, I dug a fingernail into the door. Afterward, I carefully removed a
blood-tipped splinter from under my nail, and when I got back to San

DUCHAMP'S DOOR

ÉTANTS DONNÉS

Francisco I attached it to a paper the size of a vertical business card, and had it framed with a wood frame and a double mat.

Later, I traded this work to John Cage for one of his etchings. He told me he thought it was elegant and hung it in his apartment. We agreed that its origin would be a secret. I am only revealing it now because of my Catholic guilt. This minuscule, framed object resembles my *Finger Line* drawings, only it is much smaller.

In 1987 I made a work titled *Room for Interpretation* that has some of the elements of Duchamp's *Étant Donnés*. As I was working on that installation,

I realized that the seed of it came from Duchamp. It is my pleasure to describe the connections here, but as the title implies, viewers should interpret the work for themselves.

The female torso in my work is the bottom half of a store mannequin and, unlike Duchamp's torso, is wearing underwear and is placed on a pedestal. You view it through a window in a tall, narrow freestanding french door. Behind the figure there is a large piece of raw canvas stapled to the wall. It is a drawing I made by marking it while running and jumping. The drawing has a visual relationship to Duchamp's bed of sticks.

In Duchamp's installation the female figure has only one breast showing. In my installation the one breast is represented by an antique fire extinguisher, a round glass object filled with clear liquid. It is mounted on a shelf on the wall. A yellow spotlight illuminates the figure so that it casts a dramatic shadow in the shape of a vase, the female as a vessel.

The most iconic female of all time is Leonardo's *Mona Lisa*. In Leonardo's painting, the female is seated in front of a landscape with trees, hills, and water. This is the first known portrait of a person in a landscape. Maybe the female in Duchamp's famous last work is the *Mona Lisa*. Maybe the female in my *Room for Interpretation* comes from Leonardo.

Most of my works in the '80s and early '90s were installations so it was natural to do a public sculpture. In 1988 at the Marin County Civic Center I was commissioned to make a work which I called *Observatory Bird*. I did not want to put an abstract sculpture-object in the landscape; instead I redesigned a working telescope and placed it on a forty-foot-high grassy

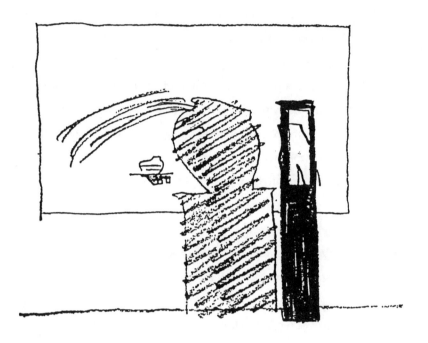

ROOM FOR INTERPRETATION

mound that I designed with a landscape architect. Three years later, in 1991, I was a consultant to the city of San Francisco for public art, and as part of my report I wrote "Notes on Public Sculpture."

NOTES ON PUBLIC SCULPTURE

Sculpture is about the relationship of forms in space.

It should grace the landscape.

Not be symmetrical.

Use the geometry of nature.

Have good proportions.

Be controversial at first.

Become a thing of pride to the public.

Have a subject.

Make a point.

Be symbolic of something.

Not be generic abstract.

Should be sensitive to where it is.

Work with its neighboring objects.

Emphasize local character.

Have a social element.

Use shadows.

Be a spirit in the dark.

It is an object that draws you to it.

Has poetry or technological information.

Predicts the future.

Allows your imagination to travel to the past.

It should bring people up to the level of art.

Fight against a world of standardization.

Have layers of meaning.

Be open to interpretation.

Not be painted red (a little red goes a long way).

It should have more than one side.

Not emit obnoxious sounds.

Consider acoustics.

Reject vandalism.

Encourage participation.

1992

My work has always had a public side and a private side. The prvate side is the solitary artist working in the studio. Others experience this work after the fact. In the public side, the audience witnesses the act of art at the moment of its creation. Sometimes this involves a social, interactive element. Drinking beer with friends and all the sculptures that include functioning bars are examples of my public, social art.

In '92 and '93, I made a functioning bar as part of an installation that breaks down into pieces that can be packed inside the bar, so the bar becomes a crate for the rest of the work. This installation, *By the Sea (The Pacific Rim)*, includes both my public and my private sides: the interactive element, graphic elements, and sculpture elements. It summarizes many of the themes that I have been working with for over thirty years.

The installation is based on an eighteenth-century painting by a Japanese artist named Ito Reigen. I saw the painting, called *Hut and Crows*, reproduced in a book about Zen art, and I recognized in it the symbols for *tree*, *bird*, and *man*, symbols that I have used often. In the painting there is a hut under a tree, with two birds flying to the left, and some writing, which describes a scene.

I divided the back wall of the installation into twelve different-sized sections, each of which is a shadow box without glass in the shape of a golden rectangle. The twelve boxes together make up a large golden rectangle.

I thought of the painting by Reigen as composed of three elements: the hut and tree, the birds, and the writing. Chinese writing was originally picture writing—the word for an animal looked like the animal. So I took the idea of

BY THE SEA (The Pacific Rim)

picture writing, and instead of writing a description of a scene I illustrated it in one of the boxes. The birch plywood back had wood-grain patterns that looked like a landscape, and I stained the wood with ink to create a suggestion of the mountains of Kweilin in China. I did the same thing in reverse in the box below, so that it looks like a reflection in the water.

In the upper left-hand corner are two of my drum brush drawings, which look like two birds. The center has empty panels at the top and bottom, and in between is a panel that is tilted slightly in the box, like a drawing table. On it are three lines, which in the original Japanese drawing would have been branches of the tree. Continuing one of them, in the top panel on the far right, is an actual branch, and under it the shadow of the roof of the hut.

The hut, of course, is a bar. I build bars. This one has a roof made of sticks, like a thatched roof. Under it, seeming to support its shadow, is a

tall, narrow, framed rolled-up canvas scroll, which represents writing and knowledge. On the bar top, under glass, is a map of the world. My map has Asia in the center and Europe on the left. At the right is the Pacific Coast of the United States. The map excludes the East Coast, which is not part of the Pacific Rim.

1996

After John Cage died in 1992, I remembered that he had been pleased that I was carrying on the work of Duchamp, and I began thinking about expanding my interest in Sound Art to create a concert that would be a way of carrying on Cage's work, in my fashion.

In 1996 I invited thirteen sculptors to my studio and formed The Art Orchestra. For four months, we met every Saturday to rehearse. The artists invented their own instruments—basically, they made sculptures that produced sounds. After I knew what everybody's instrument was, I began to write a score, based on the clock, for those instruments. Although the performers were artists who did not read music, I designed the work as a concert and not as a Sound Art show.

Sound Sculpture As, which I organized in 1970 at MOCA, was a Sound Art show. In it, nine sculptors invented sounds as concrete material. The Art Orchestra, which twenty-six years later included three of the same sculptors, was different. The setting was a concert hall. There was a score to organize the sounds, and a conductor signaled the orchestra members when to play. My intention, and that of the participants, was to make music.

The concert was in the auditorium of the Palace of the Legion of Honor

in San Francisco. The opener was an eight-minute piece of mine titled *Beer Drinking Sonata (for 13 Players)*. It was based on a work I had made ten years earlier called *From China to Czechoslovakia*, a recording in which I blew into beer bottles from around the world. In the *Beer Drinking Sonata* each player drank a bottle of Pacifico beer, and between each swig blew in the bottle to make a sound. The work was in sonata form, with three parts. The beginning part was the tune-up, with random high-pitched sounds from the full bottles. The middle part was the drinking of the beer. It started out funny, but the players were composed. As the bottles emptied, there were fewer overlapping sounds, and the pitch gradually lowered. The mood was serious, and the audience was quiet. This no longer seemed like a joke. In the third part, the bottles were empty. All together, everyone blew three times, like a chant.

The main piece, which was thirty minutes long, was called *Unity without Uniformity*, like the idea behind the Society of Independent Artists, a group of individuals. At the beginning, the thirteen players came on stage and set up. David Ng had a tennis racket attached to a small amplifier and a ball on a flexible stick (actually a massage tool) for striking the racket. Jim Melchert had a framed piece of glass, and water so that he could rub his wet fingers against the glass to make a squeaking sound. Everyone laid out the various instruments.

In the first part, behind the orchestra, Paul Kos projected video of a freight train coming toward the audience. I thought of this first part as a straight line, with the orchestra providing sound for the video. The instruments came in one at a time. The conductor, Stephen Goldstine, pointed to each one in turn, while I provided a constant rhythm with my drum

brushing. Some instruments provided the rhythm of the train; others made the squeaking and clacking sounds that trains make when they are shuffling back and forth, metal against metal. There were lots of bong sounds, snaps, drones, swishes, clicks, and barks.

The middle part was like a meandering line. The video switched to live close-up projections of the players. Howard Fried made tea from a whistling teakettle, and as he served each player, that player stopped and drank. This section was quiet, like sounds at night. Sono Osato blew into a clarinet reed attached to a block of wood, Lowell Darling blew into a seashell, and Mari Andrews clicked two small rocks together. David Ireland had a cardboard box filled with empty sardine cans and he dumped the cans on the floor with a crashing sound. That was comic relief.

In the third part, only circular instruments played: Bill Morrison had built a lazy Susan with playing cards that made a flipping sound as it spun around. William Wiley played a plastic-pipe didgeridoo that used circular breathing. Joyce Umamoto stood in the center and slowly turned in a circle, holding a sign that said "Noh Sound." Mark Thorpe had a bowl with a big ball bearing in it that he rolled around.

The last part was a short period of chaos, with everyone playing as loud as possible. The concert ended gradually as the players one by one packed up their instruments and left the stage. Mike Dyar was the Zen musician of the group. He was sitting on the floor with feathers and sticks and pieces of bamboo, and it took him a long time to pack up. He was the last one to leave the stage, and he was hamming it up a little bit. Offstage, we were trying to find a hook to drag him off.

This concert was billed as "Good Old-Fashioned Avant-Garde." It was a

collaboration of artists doing things they normally don't do, inventing sounds the way they might have conversations. There is real joy for me in working with other artists to make an event a work of art. There is public art and there is private art. I need both.

2001

After growing up Catholic, I rejected the Catholic Church because it tried to control my impure thoughts and because I realized that its business interests come first. Even at the mass for my father's funeral, the priest made a pitch for money. Later I developed a new interest in the spiritual.

Living in California, it was impossible for me not to be influenced by Asian culture. Being on the Coast makes it easy to mix European style with Zen philosophy. When you're coasting, you get momentum from the flow of the road under you. I like the simplicity of Zen philosophy and that it doesn't take itself too seriously. And its soul, or spirit, is in nature.

The geometry of nature, also known as sacred geometry, or the golden mean, is based on the way seashells, flowers, and other natural forms grow. It fits perfectly for me in my sculpture. The pyramids and the great cathedrals of Europe were derived from it. If we think an object has good proportions, it usually has the proportions of things found in nature.

The golden rectangle, which is based on the golden mean, is simple to make. First you make a square. Then, find the center of the bottom side and use that spot as a pivot point. With the point of your compass on the pivot point, draw an arc starting at the top right corner of the square, passing through the top left corner, and continuing down to the ground line.

That point on the ground line is the bottom corner of the long side of the golden rectangle

In the past ten years, I have made several sculptures based on this proportion. *Golden Rectangle with Boomerang* is a gold-plated piece of copper hinged to the wall, with a gold boomerang balanced on top to reflect itself in the rectangle. It suggests returning to itself. *Golden Wing* is made of 300 yellow butterfly wings on a piece of wood that is hinged to the wall and swings out from it. *Golden Rectangle* is a wooden shelf unit filled with 132 yellow-labeled bottles of Pacifico beer lit with a yellow spotlight.

The Greek symbol pi relates to the golden rectangle. It represents the ratio of a circle's circumference to its diameter. Pi is a number without end that does not repeat any sequence, so far as anyone has been able to calculate. Using a homemade supercomputer, two brothers named Chudnovsky calculated it to 8 billion digits in 1996 and a year later other mathemati-

GOLDEN RECTANGLE

cians calculated it to 51 billion digits. None of them found an end to the number. In 1986, I made a drawing by writing the character pi with the backside of a feather dipped in red ink. For me, the symbol of pi represents

GOLD BOOMERANG

the mathematical equivalent of God, like the cross does to Catholics.

I am designing a large white structure called *Temple of Geometry* for an exhibition in 2004 at the Center for the Arts in San Francisco. The structure is based on the golden rectangle and is made up of three cubes of different sizes. The front side has a low passageway. After you walk through the passageway you exit on the other side without entering the structure. It's an enclosed form composed of three cubes lit with yellow light from one

PI

side. The yellow light casts blue shadows. That's the way colored light works; the complementary color shows up in the shadows. Nature is present in the form of proportion.

The '90s was a decade of "neo" art: neo-Pop, neo-Conceptual, and neo-Surrealism. That age ended on September 11, 2001. Since the terrorist attack on the U.S., all grievance art that whines about the unfortunate life of some artists (or their ancestors) is over. Save-the-world-art that is naive and self-serving will have to become relevant or fade away. By seeing things in a new way, artists have the ability gradually to bring about change in the

TEMPLE OF GEOMETRY

world. Poetic gestures, in the end, can influence the people with money and power who are in a position to make actual change. We are waiting for the next generation of artists to come up with a new form or style or material.

Some artists younger than me complain that "it's all been done before." But someone comes along every once in a while and puts something out there that nobody ever thought of. In the '60s when Carl Andre used bricks as the subject of his art, and Dan Flavin used lighted fluorescent tubes, it seemed that all the materials in life had been claimed. Then an underground Conceptual Art movement was born, and by the early '70s a new field had opened up. By the end of the '70s, after art had become so close to real life that it was invisible to most of the public, painting returned to the

marketplace and retreated into safe old styles. That was the first "neo"—neo-Expressionism.

The "neo" art of the '90s is a kind of neo-Conceptual Art. It has a strong emphasis on juvenile subject matter: little boy or little girl art, toys, dolls, cartoons, hip-hop culture. More recently the big international exhibitions have been dominated by a variety of "expo" art. Peter Schjeldahl, writing in the *New Yorker* magazine, calls it "festival art." Many art galleries and museums have become fashion-conscious, market-driven spectacles, with video projections in darkened galleries where you can't even ride around in bumper cars. They have movie theaters with no seats and high-tech rooms that attack you for your attention.

At some point, artists and their art became material for the installations of a few curators. As those curators began to think of themselves as artists, they used fine art, folk art, and objects from popular culture as their mate-

INSTRUMENT OF WAR

rial, and presented them together, confusing the public about what art is. I don't like to sound pedantic but I believe art is a poetic record of the culture with the power to inspire people to a spiritual awareness. I also think art represents the culture's most excellent examples of visual ideas. You cannot pretend that art and nonart are the same.

Art can become serious again. Even art with wit and art with beauty should have political content, have a subject, make a point, and not be an ornament. Picasso said when he painted his *Guernica* in 1937 that "painting is not done to decorate apartments; it is an instrument of war. . . against brutality and darkness."

WHAT IS ART FOR?

For beauty,

For history,

For decorating apartments.

For people to laugh at,

For imitating nature,

For therapy,

For seeing in a new way.

For an educated audience,

For enlightenment,

For political agendas.

For glorifying the church in the Renaissance,

For glorifying the state under communism,

For glorifying the rich in capitalism,

For recording society in a poetic way.

EPILOGUE

Something happened to me recently that many artists have experienced. I was included in a group show in a new museum dedicated to food, drink, and art that was founded by a big winery in Napa, California. My work (*Golden Rectangle*) was a shelf unit filled with empty beer bottles with yellow labels. It was supposed to be lighted with two yellow spotlights. After I saw the show, I sent the following email message to the curator: "I think you forgot the yellow lights on my work."

He emailed back: "We didn't quite forget the yellow light; in fact it was a conscious decision not to use it. We felt that *Golden Rectangle* already looked so good and was such a draw to visitors who see it through the gallery door that we would actually lessen the impact with a yellow light. I intended to call you to discuss our thoughts, but I'm afraid my mind moved on to future exhibitions. I do hope you will not feel that we interfered with your concept. Our intention is always to present works of art to their maximum advantage. We are pleased and honored to have your work included in [the exhibition] and I hope we will have future opportunities to bring you and your work to [our museum]."

I emailed him with this message: "The yellow light was not an afterthought. Many of my sculptures are lighted with yellow light. It's a signature with me. Did you light it with yellow light and then decide it looked better without it? The work looks good the way it is, but it looks better with yellow light the way I intended it. I understand the lighting is usually the job of the installer, but in this case the yellow light is a component of the piece. It's not the job of the curator to change an artwork to try to improve it. But don't feel

bad. It happens to me all the time." An artist tries to have control over how his work is seen. Even if a curator wants to try to help the artist out by changing something intended to improve it, it's still the artist's work.

Years ago, when I was a curator, I used to go to museum conferences. At the end of the day when we were drinking in the hotel bar, the museum folks would talk about how difficult it was to work with artists. Some of them felt lucky if they worked on exhibitions with only dead artists. Since I was a live artist (I worked under the pseudonym of Allan Fish while I was a curator), I felt like a spy. They were talking the way any group talks when nobody outside the group is around, speaking freely. In a 2002 movie called *Barbershop* white people got a glimpse of how black people talk when no white people are around. For instance, there is a difference between a big-ass woman and a woman with a big ass.

Sometimes at my Wednesday salon parties there is a moment when only men are present, and it becomes an opportunity to talk about girls without concern for the politically correct terminology. I'm sure women do the same thing when there are no men around. But I created a salon for men and women; an early definition of a salon is a place where men and women can talk on an equal basis. We talk about jazz and art, tell jokes and lies, smoke and drink. The cigar smoke adds to the intoxication in the room. I'm going for a mood.

A French visitor told me that my space was elegant without being bourgeois. The lights are on a rheostat; the floor is hardwood stained dark walnut. The bar is dark and curved so people can see others at the bar; the booths are red and curved to create a second group. The ceiling is thirteen feet high. The bathroom looks like a gallery. Behind my desk is an art

library with a blue MOCA neon sign. I have an upright grand piano that gets played sometimes. When a workman was working in my studio he said, "Is this going to be a lounge?"

I play music that I recorded on continuous-play tapes so that it seems like a jukebox is always on. The music I play is modern Jazz—by "modern" I mean late '40s bebop through mid '60s hard bop. Once in a while I sneak in some classical music to change the mood for a few minutes, and sometimes I play a tape I made of sounds from Breen's Bar in the '70s. People start to talk more when there is recorded talking. It sounds like a lot of people are in the room and it picks up a slow party.

This is a private club. The guest bartender can invite up to three friends, so some new people are introduced to the group for that week. Sometimes a guest clicks with the group. People usually know if they add to the buzz of the scene or not, if the chemistry is right.

I don't really have an ending to this book because I have many more years to live. When George Burns was ninety-nine years old he was asked this question: "You smoke nine cigars and have two martinis a day, what does your doctor say about that?" Burns said, "My doctor's dead."

The comedian George Carlin said, "The job of the comedian is to find where the line is drawn, deliberately cross it, and make the audience glad you took them with you."

I would say that's the job of all artists.

JAZZ

GALILEO'S FINGER

FEATHER WRITING

CINCINNATI MIRÓ

OBSERVATION PLATFORM

A DOOR MUST BE EITHER OPEN OR CLOSED

MAN RAY LOOKS TO DUCHAMP

EAR DRUM AND SOUND WAVE

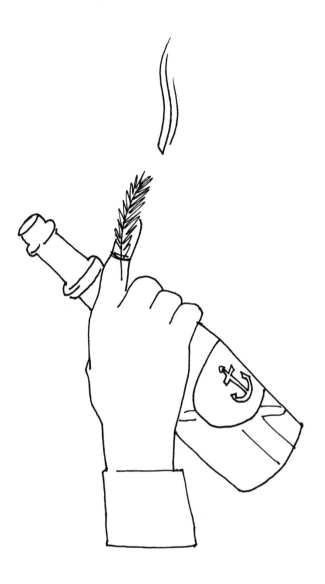

SAN FRANCISCO BEER

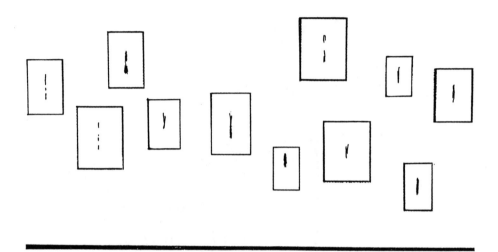

11 LINE DRAWINGS

Tom Marioni

Tom Marioni

Tom Marioni

MY NAME WRITTEN BY JOHN CAGE, JOSEPH BEUYS, ANDY WARHOL

BEER DRINKING SONATA

(for 13 players) 1996

Allegro. Thirteen bottles are lined up on a table in front of the performers. The performers stand in a semicircle around the back of the table. Each performer opens a bottle of beer; the bottle opener is passed around the table. All the bottles are the same size, long neck, (Mexican "Pacifico" if possible). On cue, all together, the performers blow into full bottles with a short burst as if tuning up.

Adagio. The players blow once into their bottles after each drink (swig) until the last performer finishes. The performers drink at their own rate so the sounds are random. After each drink, the sound is different from the one before and from the sounds of the other players. As each player finishes the beer, the player puts the bottle on the table.

Rondo. When the last person finishes drinking, all the players pick up their empty bottles and on cue all blow together three times into the bottles. The piece takes about 8 minutes.